Denver Art Museum

November 21, 1979—January 13, 1980

Poets & Painters

Organized by Dianne Perry Vanderlip

Essay by David Shapiro

Participating Museums

William Rockhill Nelson Gallery
and Atkins Museum of Fine Arts
Kansas City, Missouri
August 15—September 28, 1980

La Jolla Museum of Contemporary Art
La Jolla, California
October 17—December 1, 1980

© Denver Art Museum 1979
All rights reserved
Printed by Citron Printing Company, Denver, Colorado

Library of Congress Catalog Card Number: 79-55555
ISBN 0-914738-17-8

Cover: Philip Guston, *Allegory*, 1975,
oil on canvas, 67 1/2 x 72 3/4 in.
David McKee Gallery, New York.

The productive interaction of artists and authors, poets and painters, has persisted for centuries. Even artists of different eras have found sympathetic stimulation in each other's ideas and imagery. William Morris, poet, painter, and founder of the Kelmscott Press, produced brilliant illustrations for the works of Geoffrey Chaucer, and one recalls Picasso's extraordinary suite of etchings for Ovid's Metamorphoses.

This exhibition sets forth to explore the nature and prevalence of cross-stimulation among today's poets and painters. The vitality of these relationships and the diversity of the work produced from them is self-evident. I am profoundly grateful to Dianne Perry Vanderlip, curator of contemporary art, for her initiative in conceiving the exhibition and her intelligent and perceptive realization of it. The exhibition marks a new step in our efforts to examine important currents in the art of our time and to contribute increasingly to the cultural knowledge of the nation. Circulation of this and future exhibitions in a variety of fields of art is an essential element of our goal to participate fully in the artistic life of the country.

Thomas N. Maytham
Director, Denver Art Museum

Foreword

It should come as no surprise that the idea for this exhibition and catalog grew out of the enthusiasms and philosophical sympathies of two artists, each passionately committed in both his life and his work to perpetuating nineteenth-century symbolist attitudes about the congruence of poetry and painting. Several years have passed since Jarry Crimmins and Tom Chimes spent countless hours discussing with me the historical life of these attitudes and the renaissance they seemed to be experiencing in the 1970s. The vigor of these discussions fired my eagerness to do this exhibition, and my sincerest thanks go to both artists for acting, as artists often do, as catalysts.

Interaction among the arts and among artists of various disciplines is not new, of course. The close relationship between poetry and painting has been remarked since classical times although then, as in the myriad treatises on art and literature written between the sixteenth and eighteenth centuries, the comparison rested chiefly on the vividness with which both arts imitated the exterior world of nature.[1] The Romantic idea that all the arts are really one, that they grow out of and synthesize a shared human experience, was taken up later in the nineteenth century by Walter Pater, who argued that music was the central art on which the others were converging and who hailed Wagner's music drama as the perfect expression of this tendency. Even in the eighteenth century, however, Lessing (*Laokoön*, 1766) had pointed out that the visual and literary arts served separate functions and could never be really congruent since they exist in the two distinct dimensions of space and time. It was inevitable that the truly revolutionary attempt of the French symbolist poets to adopt the *techniques* of painting should come under vociferous attack by critics who shared Irving Babbitt's view that a coalescence of the arts was neither possible nor desirable (*The New Laokoön*, 1910).

But, despite theoretical arguments against a unity of the arts and despite their practical awareness of the unique properties of each discipline, twentieth-century artists have continued to seek a rapport between the various arts which would do more than acknowledge their ability to represent the same subjects. Some of the richest and most celebrated moments in this century's cultural history have occurred when practitioners of different arts have influenced each other's work. Occasionally, this influence has resulted quite simply from the real admiration and understanding one artist has had for the accomplishments of another. Sometimes, it has been exerted through close collaboration on a joint project. Poets and painters have frequently worked together in this way, often expanding or even transcending the traditional boundaries of their arts, at other times achieving a true synthesis of the two. These poet/painter kinships have, in many instances, served to define major issues in contemporary aesthetics and in the practice of both arts.

The synergistic environment of Paris in the early years of this century owed much to the efforts of Guillaume Apollinaire, the great turn-of-the-century poet/critic who brought together in fruitful relationships those artists who would lay the foundation for an avant-garde that would emphasize the "marriage" of the arts defined here by David Shapiro. Credited with introducing Braque to Picasso in 1907, Apollinaire championed the modernist painters, writers, and musicians of his day in a succession of influential articles. In his writings, especially *Les Peintres cubistes* (1913), the first major document in defense of the cubist painters, and through activities like the organization of the cubist room at the Salon des Indépendants in 1911, he gave voice and solidarity to the fabric of ideas being explored by his painter colleagues.

Shared political and philosophical positions, as well as shared aesthetic points of view, have sometimes formed the basis for alliances between poets and painters. Although Apollinaire had coined the word *surrealism* as early as 1917 in his preface to the Cocteau/Picasso/Massine production of Satie's ballet, *Parade*, André Breton's manifesto of 1924 first defined the term in relationship to the complex movement "which was conceived not in order to achieve esthetic 'progress,' but to revolutionize society at every level."[2] Referred to as the "pope" of surrealism, Breton had not even included the visual arts in his original vision of the movement.

Surrealism, as he defined it, was "pure psychic automatism, by which it is proposed to express *verbally*, in writing or any other way, the actual workings of the mind. A dictated record of the mind, in the absence of any control exercised by reason, over and above any aesthetic or intellectual preoccupation."[3] But the December 1924 inaugural issue of the surrealist journal, *La Révolution surréaliste*, contained a column which was conceived as a regular feature on literature and the fine arts. Although Max Morise argued here that there could not be a pictorial analogue to automatic writing because painting demanded too much conscious organization, a "coherent body of surrealist painting was already coming into existence."[4] And it was not long before the concept of collaboration to stimulate inspiration became an integral part of the collage aesthetic which animated surrealist art. Throughout one of the richest, yet continually misunderstood periods of modern art history, poets and painters like Louis Aragon, Max Ernst, Man Ray, Francis Picabia, Giorgio de Chirico, and Paul Eluard gathered together to quarrel, share, dream, explore, and offer mutual support and inspiration. They created a living collage of energy and ideas that, along with cubism, became one of the major touchstones that artists would refer to for years to come.

The Paris salon hosted by poet Gertrude Stein and her brother Leo in the first decades of the century brought together poets and painters from both Europe and America. Not only were the Steins able to provide welcome patronage, but they also dispensed open-handed hospitality in an atmosphere conducive to productive conversation. Committed to spreading the gospel of modern art and to acquiring the works of the guests who regularly visited their home at 27, rue de Fleurus, the Steins offered encouragement to a score of struggling artists. If their Saturday night soirees did not exactly change the course of art history, the gathering together of Picasso, Matisse, Apollinaire, Alfred Maurer, Marsden Hartley, Jean Cocteau, and others did create a forum for the exchange of ideas and a sense of camaraderie among visual artists and literary figures that has never been equaled.

In this country, the home of William Carlos Williams, full-time physician and painter-turned-poet, provided a setting during the twenties and thirties for artistic interchange very similar to that of the Stein salon. Williams's decision to practice medicine in the small community of Rutherford, New Jersey, was influenced by his desire to know and understand grass-roots America. Weekend visits to New York galleries brought him into contact with some of the European artists who had left France to escape World War I. Soon, an international group of patrons and artists gravitated to his home: art patrons like Walter and Louise Arensberg; the expatriot artists Marcel Duchamp, Albert Gleizes, and Man Ray; and the Americans associated with Stieglitz's Gallery 291, Georgia O'Keeffe, John Marin, Paul Strand, and Arthur Dove, as well as some outside the Stieglitz circle like Stuart Davis, William Zorach, and Walker Evans. Williams was more interested in bringing these people together to discuss the underlying aesthetic principles of their art than he was in the works of art themselves. Few of the group sought Williams as a leader or as an example to follow, and "in no way did he ever become an André Breton, a 'magus of surrealism,' dispensing favor or ultimatum according to an established program. As a consequence, the artistic and cultural significance of . . . [the relationships Williams fostered] is characterized much less by influence than by confluence, artists coming together to share, discuss, argue, and of course, disagree about the making of art."[5]

More recently, the best-known relationships between poets and painters were surely those established by Frank O'Hara with the New York School. Frank O'Hara, poet, mentor, friend, lover, and collaborator, was undoubtedly, as David Shapiro points out, one of the legitimate children of Apollinaire. As such, he became, if not the spokesman for the artists he was involved with — De Kooning, Michael Goldberg, Norman Bluhm, Jackson Pollock, Franz Kline, and others — certainly the conduit through which their energies, lives, and ideas passed during the artistically intense fifties and early sixties. O'Hara, who had been a curator at the Museum of

Modern Art before his tragic death in 1966, found time to write his poetry on lunch and coffee breaks. His description of those intense years is quoted on the back jacket of Marjorie Perloff's recent book:

> We were all in our early twenties. John Ashbery, Barbara Guest, Kenneth Koch and I, being poets, divided our time between the literary bar, the San Remo, and the artists' bar, the Cedar Tavern. In the San Remo, we argued and gossiped; in the Cedar we often wrote poems while listening to the painters argue and gossip . . . An interesting sidelight to these social activities was that for most of us non-Academic and indeed non-literary poets in the sense of the American scene at the time, the painters were the only generous audience for our poetry, and most of us read first publicly in art galleries or at The Club. The literary establishment cared about as much for our work as the Frick cared for Pollock and deKooning, not that we cared any more about establishments than they did, all the disinterested parties being honorable men.[6]

And so it has been throughout this century . . . poets and painters coming together and serving as catalysts to advance, expand, and mutually reinforce each other's ideas.

Poets and Painters aims to explore the continuation of that tradition into the seventies, which are, of course, as different in spirit and content from preceding decades as each of these has been from the others. No prevailing aesthetic dogma or attitude characterizes the present decade, a period aptly described by Alan Sondheim as one of "post-movement art."[7] Even the relatively few artists included here share no unifying philosophical bias. What they do have in common is a sensitivity to and committed interest in the work of artists pursuing a different discipline. Some of them seek to incorporate the means and materials of poetry, or painting, into their own art. Others attempt to break down the barriers separating the two disciplines, and still others deny that any such barriers ever really existed.

In organizing the exhibition, I asked twelve poets whose work reflects a serious involvement with the visual arts to select for inclusion painters to whom they felt a special affinity. Additionally, the poets agreed to write, in whatever form they chose, a piece about the artists they selected. These works, poetry and prose, have been published here opposite reproductions of the work of the painters who inspired them. The catalog and exhibition should be viewed as a collage of images and ideas, reflecting many different poetic and painterly concerns, styles, and interests. Even more, the exhibition demonstrates the openness, diversity, and multifaceted nature of the alliances between poets and painters in the seventies.

The final success of *Poets and Painters* springs from the enthusiastic support of its participants, both poets and painters. The poets supplied us with new works, written especially for the exhibition, and the artists carefully selected works that would be most appropriate to the concept of the show. The evolution of the exhibition has been a truly collaborative effort among thirty-seven artists, and I am deeply grateful to have had the opportunity to share in this process.

Throughout the development of the exhibition, many tedious questions arose and many sources of material had to be discovered. To avoid harassing every participant in the show, I relied upon an unfortunate few as my main sources of information—and inspiration. Peter Schjeldahl, David Kermani, Irving Sandler, Bill Berkson, Doug Walla, and the late Tom Hess were incredibly patient and helpful in responding to my continual questions. Very special thanks are owed to David Shapiro, who, in addition to writing the superb essay, "Poets and Painters: Lines of Color," that illuminates this catalog, has been extremely generous with his time, help, and enthusiasm.

We have borrowed photographs and reproductions from many private and public collections. We would like to acknowledge loans of this material from Mme Marcel Duchamp; John Ashbery; Bill Berkson; John Gruen; The Museum of Modern Art; The Poetry Collection, Lockwood Memorial Library, State University of New

York at Buffalo; The Gertrude Stein Collection of American Literature, Beinecke Rare Book and Manuscript Library, Yale University; The Philadelphia Museum of Art; and Skira/Rizzoli International Publications, Inc., New York.

Private collectors and dealers were extremely generous in making paintings available to us for inclusion in the exhibition. We are grateful to Larry Rivers, New York; Robert Rauschenberg, New York; Awilda and Michael Bennett, New York; Robert C. Hobbs, New York; the Lehman Brothers, Kuhn Loeb, New York; Max Hutchinson Gallery, Houston; Fischbach Gallery, New York; Marlborough Gallery, New York; Xavier Fourcade, Inc., New York; Pam Adler Gallery, New York; Holly Solomon Gallery, New York; Nancy Hoffman Gallery, New York; David McKee, New York; Brooke Alexander, Inc., New York; Pace Gallery, New York; Castelli Gallery, New York; and Gemini Editions, Los Angeles.

Finally, my personal thanks go to the staff of the Denver Art Museum without whose help this exhibition would not have been possible. First, of course, I am grateful to Thomas N. Maytham, director of the museum, for the support he offered in all phases of the project.

Deborah J. Allen, my assistant, deserves a great deal of credit for the success of *Poets and Painters*. Her sustained involvement with both the exhibition and the catalog was essential, for she organized all the necessary research as we were developing the idea and handled the voluminous correspondence and coordination of materials from twelve poets and twenty-five painters with sensitivity and efficiency.

Marlene Chambers, director of publications, was responsible for the arduous and sometimes apparently impossible task of organizing and editing all of the written material included in this catalog, as well as directing its production. Her outstanding professional expertise, personal enthusiasm, and patience helped to create a catalog which we believe will be an important record of the poet/painter relationships of the seventies. She has my sincere admiration and thanks for

successfully managing a difficult job. Carol Rawlings, editorial assistant, helped to lighten the editorial load, and her contribution is much appreciated. Thanks, too, to Amelia Ives for the hours she spent designing this fine catalog.

L. Anthony Wright, registrar, and his assistant, Susan Mundt, worked very hard to ensure that all the works in the exhibition arrived on time and in good condition. They also made the arrangements necessary for the safe, expedient moving of the exhibition as it travels to the other museums included on the tour.

Financial support for *Poets and Painters* was provided by generous grants from the National Endowment for the Arts, Washington, D.C., a federal agency, and The Kulchur Foundation, New York. Their assistance is deeply appreciated.

Dianne Perry Vanderlip
Curator of Contemporary Art
Denver Art Museum

Footnotes

1. Rensselaer W. Lee, *Ut Pictura Poesis: The Humanistic Theory of Painting* (New York: W. W. Norton & Company, Inc., 1967), p. 4.

2. Lucy R. Lippard, ed., *Surrealists on Art* (Englewood Cliffs, New Jersey: Prentice-Hall, Inc., 1970), p. 4.

3. André Breton, in Gaëtan Picon, *Surrealists and Surrealism 1919-1939* (New York: Skira/Rizzoli, 1977), p. 61. Italics mine.

4. Picon, p. 69.

5. Dickran Tashjian, *William Carlos Williams and the American Scene 1920-1940* (New York: Whitney Museum of American Art, 1978), p. 16.

6. Marjorie Perloff, *Frank O'Hara: Poet among Painters* (New York: George Braziller, 1977).

7. Alan Sondheim, ed., *Individuals: Post-Movement Art in America* (New York: E. P. Dutton & Co., Inc., 1977).

Poets & Painters: Lines of Color

Theory and Some Important Precursors

Vowels

A black, E white, I red, U green, O blue: Vowels,
One day I will talk about your latent births:
A, black corset in velvet for the flickering flies
That buzz around sadistic snells,

Shadow gulfs; E, whiteness in mists and tents,
Proud glacier's points, white kings, shuddering parsley;
I, purple, spat blood, beautiful lips laughing
In the anger or drunkenness of guilt;

U, waves, the divine shivering of chrome green seas,
Peace of the pastures sown with animals, peace of the wrinkles
Alchemy stamps on the great studious foreheads;

O, supreme Trumpet full of wild stridencies,
Silences crossed by Worlds and by Angels:
— O The Omega, violet streak of Her Eyes!

Arthur Rimbaud
translated by David Shapiro

The marriage of poetry and painting is a good one. Sometimes the two arts, it is true, have been seen as sisters, with all attendant jealousies and bickerings. We choose to see them as partners, sometimes softly affectionate toward each other, other times in a passionate union as fruitful as the earth. One of the immense mysteries of the arts is the way in which they are not only like each other (Horace's *ut pictura poesis*) but the way in which they are always already each other. In some cultural ages, the partners have harped upon their differences; in other ages, they have stressed the sweetest correspondence. And again, at the happiest of times, the congruence of poetry and painting has been established.

Both poetry and painting may be said to be a reticence, an opacity, and a separation. Perhaps it is inevitable that a Chinese poet is credited with the first screen. The screen in art and literature is a constant, a sense, as Théophile Gautier put it, of the frontier of fire that separates spectator from illusion. Contemporary artists are often involved in strategies of self-consciousness and self-reflection that are not merely self-preoccupations. Just as Marcel Duchamp was involved with precedent situations that open and close simultaneously and false windows called "widows," so poets such as John Ashbery are involved in distortions, sudden manneristic interruptions, and framing devices. Both painting and poetry are fire screens against chaos: curtains, shadow plays for Prufrockian nerves. In both painting and poetry, the division of space is involved. While poetry seems the exclusively temporal terrain, the perception of painting is not exclusively simultaneous and may purposely be disrupted. And also poetry may be reduced to an atomistic glimpse. From Whistler to Johns, from Mallarmé to Ashbery, the creator plays shade on shade, tracing, it may be, the radiant and troubled intelligence it separates and unifies.

The linguist and literary historian Roman Jakobson has made some of the most penetrating remarks concerning the relations of poetry and painting.[1] For Jakobson, citing a whole wealth of linguistic scholarship, grammar is comparable to geometry. The poet must take a stance for or against grammar, but he cannot escape its

rule systems. And so the artist is locked in a constant and ohitting dialectical *agon* with the forces of geometry. Jakobson has also made some beautiful studies in synaesthesia, the correspondence of different senses.[2] He has found, in some elegant, empirical studies, that vowels in language are perceived by different speakers as having similar color qualities. Thus, language at its very phonological heart is a principle operating upon some sensitive speakers with painterly force. The rise of those poets who have emphasized such musicalist qualities is thus comparable to the rise of painters emphasizing designs of pure color in a nonmimetic mode. Jakobson sees poetry as largely nonmimetic and even often antimimetic. Too often poetry is compared to painting only in its descriptive function. But Jakobson, seeing poetry as a palpable form that is filled with repetition and equivalence as its central principle, at least removes the descriptive as the dominant element in the marriage of poetry and painting. However, Jakobson is the maturest of formalists and sees that poetry never entirely gives up its referential possibilities.

Jakobson sees metonymic displacement as one of the great devices of poetry. Boris Pasternak's poetics is almost completely constituted by the tilting of spatial arrangements. This metonymic disordering is certainly one of the constant resources of painting. In *Hang-up* by Eva Hesse, a looping metal bar comes out of an empty but bandaged frame. Our expectations are humiliated in a variety of ways. The painting seems to be missing and only the frame presented, and the metal rod reminds us more of sculptural attack than of painting. The famous Joseph Cornell box in which a ship's mast is taken over by or as a spider web is a similar metonymic disordering. It is true that the metaphorical is also present, and the comparison and contrast of web and sail are made to carry a whole aggressive pun against the viewer. Giorgio de Chirico's novel, *Hebdomeros,* is filled with metonymic and metaphorical displacements. His immense sentences have been said to influence Ashbery's most recent prose. De Chirico's own empty paintings, with their deliriously long arcades, their picture-within-picture, their mannequins and geometrical modes, were too dislocating

even for the painter himself, who retreated into more conventional, neoclassical modes. In painting and poetry, according to the linguistic usage, both contiguity and similarity are poles.

Poetry in our own day insists on its written character. Certain French philosophers, such as Jacques Derrida and Julia Kristeva, have spoken of all of Western culture as suffering a crisis and passing away from its centered quality, in which God himself serves as sounding principle. Speech is seen as constantly preferred in Western culture, and poetry as idolizing its spoken qualities as opposed to its graphic nature. But the lapse of Logos, the end of an age of harmonizing mythologies, erupts as a graphic revolution. Nietzsche's aphoristic style is really a precursor of all collage. Walter Benjamin dreams, for example, of a criticism that will be pure collage. The poet presents in such an age "found" poetry, bits and pieces of everyday language untampered and untrammeled by mere hand. The written quality of the page emphasizes its relationship with the portable canvas. On it, the poem is a kind of figure seen upon a ground of whiteness. In certain poets such as Mallarmé there is the desire to reach an almost spectral absence of figure. "Mallarmé/Had too much to say/He never quite/Left the page white," said W. H. Auden in a witty *morceau de salon.* The philosopher Derrida perhaps exaggerates in a neo-Nietzschean mood. Nor are many willing to see speech and representation as merely deposed in an infinite play of forces. Still, speech and writing as polarizing activities are large ways to think about our poets and also our painters. Self-reflective painting is perhaps analogous to a self-conscious *written* work of poetry. Painting that, in a sense, loses itself in illusion may be yielding to the myth of depth seen in speech. Note how some of our most populist poets associate themselves with public oration (Allen Ginsberg and Yevgeny Yevtushenko) and our most private with unyielding *écriture.*

The critic-editor Joseph Masheck has talked of the cruciformality of painting, its central sense of itself as a rectangle with all the concomitant problems of the figure and its displacement. It may be said that poetry too is

haunted by the cruciform. Our words proceed in a *verse* and turn toward the horizontal. One axis of poetry and the other meet and mingle, says Jakobson, as two neighboring lines become metaphors for each other and not mere cause and effect. Thus, the metaphorical and the metonymic are central crosses for poetry. Each word in a sentence may be replaced by a kind of metaphor for itself. Each word also fits into a temporal sequence. Thus, the temporal sequence and the simultaneity of language are other crosses for poetry to bear, if I may speak figuratively. A Heideggerian sees poetry as a figure upon silence, and indeed a materialist way of thinking of the problem would be to see all painting as a form of writing upon the canvas-page. Cy Twombly has hypostatized this situation and produced paintings which look like Palmer exercises. Jim Dine constantly scribbled words and phrases upon the canvas in a pun of paper and canvas. Interestingly, just when painters shape their canvases to idiosyncratic forms, poets produce poems in new stanza forms and on strange sites: poems on walls, carvings on architectural models, graffiti-esque pronouncements, etc. The two-part painting of extreme disruption is also paralleled in the split texts for simultaneous voices by John Giorno and Lofriui and in Ashbery's new "Litany." The harping upon the margins in poetry resembles the "edge" problem in art.

Perhaps the central cross for poetry to bear, underlined by Ferdinand de Saussure and Jakobson as linguists, is the distance between signifier and signified. That is, any word bears only a differential meaning in its language and does not have absolute designating status. It may be that a word in this sense refers to an object only in the indirect way that a form in painting refers to an object: by arbitrary convention. Both painting and poetry are always already public languages, semiotic assemblies of differences among meanings. Even a blank page and a blank canvas may be historically determined items and may mean different things in different cultures. In a Tantric mode, a blank canvas might mean an undifferentiated continuum that is Atman. In a contemporary culture, a blank canvas may be a political or personal protest or mimesis of chaos. In short, the poem cannot reach over to the external universe except

through tradition in its inveterate material hold. This is in no way to disparage the mimetic, and Jakobson has held that the visual arts lead easily to the iconic, in Charles Peirce's sense, that which mimics the so-called original. But language, like music, may lead more inexorably toward the symbolic and the arbitrary. In our own day, the best critics and practitioners have often seen in a pluralistic sense an art work not as a site for puristic reduction but as a site of difficult profusion. In this sense, every poem and painting is not merely an autonomous world but a profoundly open and even political site of meaning-formation. Critics of pluralistic zeal are rare, but some have arisen to use both psychoanalysis and sociology as tools in the materialist critique of art.

For the student of contemporary art and literature, the central historical periods that need to be stressed are possibly the French symbolist period of the middle to late nineteenth century, the Dada and surrealist adventure after the First World War in a variety of countries, and the period of abstract expressionism in New York after the Second World War.[3] In a more random collage of documentation for this exhibition, one could stress many other periods. Jakobson has drawn attention to the most marvelous of poet-painters, William Blake, who presented illuminations that were indissoluble, verbal-visual icons. Goethe's studies on color could furnish a specimen text of the writer critically examining the physiology of perception. Islamic calligraphy is an entire volume of another culture in which we see the happiest rapport between script and image: a horse built entirely of sacred words carries a diminished self also "collaged" from letters. The Chinese poet-painters influenced modern thought directly and through translations by Ezra Pound, Arthur Waley, and Ernest Fenellosa. Each Chinese ideogram was perceived as a concrete presentation, a rich palimpsest of meanings. "Shaped" poems have been discovered in a variety of epochs, from Kabalistic visions to George Herbert's "Easter Wings" and the most recent "concrete" poems. But the central path, perhaps, for the current pluralistic maximalism that this show recovers is seen in the international matrix that

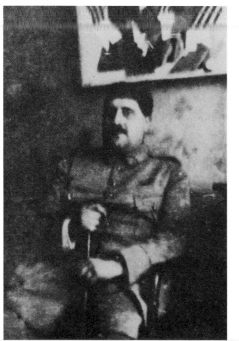

Guillaume Apollinaire in Adrienne Monnier's Paris bookshop, La Maison des Amis des Livres, 1916-1917. Courtesy of Skira/Rizzoli International Publications, Inc.

Below: Gertrude Stein and Basket, Alice B. Toklas, Picasso and son Paulot, M. and Mme Georges Maratier, photographed during the 1930s by Mme Picasso. Courtesy of the Gertrude Stein Collection, Yale Collection of American Literature, Beinecke Rare Book and Manuscript Library, Yale University.

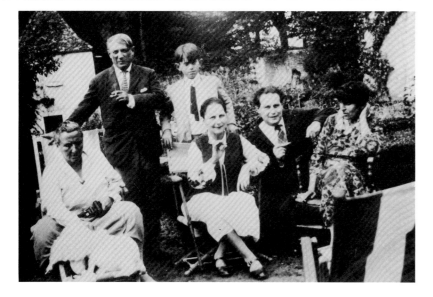

stretches through symbolism to conceptualism. Baudelaire, Mallarmé, and Rimbaud may be said to be the truest precursors of this exhibition, along with their most legitimate offspring: Apollinaire, André Breton, Tristan Tzara, Pierre Reverdy, Max Jacob, Gertrude Stein, Wallace Stevens, William Carlos Williams.

Baudelaire was a passionate art critic, and we can find in his poems, as in the best of Gautier, the most painterly of images, the most sculpted of strophes. In his pursuit of a Paradise of phantasmagoria, Baudelaire enriched every poem with a bewildering maze of images of elevation, vertigo, and the bursting of the confines of the world. He spoke explicitly in the canonic poem "Correspondances" of the relations of perfumes, colors, and sounds. In attempting to create a rich kinship system between all the structural possibilities of the material world, he sought to gain, paradoxically perhaps, an immaterialist union and a sensuous bliss. In "Les Phares" he speaks of the great painters in an age that has lost its central Logos: Rubens, Leonardo, Rembrandt, and Michelangelo are praised in the most violent of imageries as lazy gardens, black mirrors, sad hospitals, and vague terrains. Then Watteau, Goya, and Delacroix are compared to carnivals, nightmares, and lakes of blood. The poem itself attempts to mimic the painterly glory of its topic. In Baudelaire's prose poems, one finds a true rage against the old poetic devices and the longing for a new organicity.

Mallarmé is the most radical of hermetic poets. His project was, in a sense, to remind us of the distance between signifier and signified, between a name and its object, and between sound and sense in every word. Each word is at once an arbitrary system of music and meaning. Mallarmé exploits this arbitrariness, this music to its utmost. At times we may compare him to an intimist, as the painter-critic Fairfield Porter did when likening his poems to the works of Edouard Vuillard. But at other times, his central project seems even nonmimetic or at least drastically antimimetic. His poems seem to dissolve into grammatical monstrosities without issue or object. The common expectation of sense is again and again deferred, so that one begins to presume that

nonsense itself is both a topic and a style. In his greatest poem, "Un Coup de Dès," though greatness is not exactly at issue, the poem is produced as a complete visual world. Different propositions are given different typefaces and distributed through the page as constellations of almost illogical signs. This poem, that amazed his disciple Paul Valéry so much, is a kind of key to future developments in poetry. It underlines by its title the theme of chance; it reemphasizes again and again the breakdown of usual grammatical-geometrical modes; and it attempts to sustain the theme of the abyss in a paradoxical plenitude. Modern poetry is both aphasia and the learning of language.

Rimbaud is for some a central figure in a biographical drama of revolt, but we want to see him for the purposes of this show with all constructivist bias. It is not so much his famous renunciation of literature that interests us, but his eidetic visions, noted in a new and supple prose poetry entitled *Les Illuminations*. The title itself—and it is not necessarily Rimbaud's title, for the book was gathered by others—has reminded critics both of its pietistic and antipietistic connotations and of the connotation of colored plates and prints. In Rimbaud, who often praised children's books and the cheap and gaudy colors of popular prints, color becomes both topic and style. Nothing is merely colored in; color thrives alone. And, as with the most drastic of the impressionists, every object and shadow is color. The sentences are held paratactically, with the sternest breakdown of connectives. This expunging of the connective tissue holds the widest possibilities for painting, music, and poetry. Poetry becomes something agitated and probabilistic. In the ecstatic poem "Dawn," Rimbaud embraces the summer light itself. Precious stones are animated, and the adventure is Adamic: naming is creating.

The symbolist adventure is, in a sense, full of the principle of hope. It seeks, even in the abdication of Rimbaud from the profession of poetry, an architectural synthesis. Rimbaud may have given up poetry for a life of mercantilism and voyaging, but he perceived it as the yielding of an illusionistic mode of decadence for a more

truly real mastery. Mallarmé made even of his infertility a theme of poetic presence in absence. Baudelaire's dandy is, in Walter Benjamin's words, "a secret agent in the enemy camp," every colloquialism exploding like a piece of caricature in Seurat.

One should not forget, too, that in the most explosively revolutionary of societies, turn-of-the-century Russia, immortal marriages of art and poetry commenced. The symbolist tradition had become almost a rotten thing, but it produced some of the vast symphonies of Aleksandr Scriabin in chromatic music and of Andrei Bely in novelistic rhapsody. But it is a phenomenon known as Russian cubo-futurism to which we must turn to see the inordinate effects of the rapport between the arts. Russian poets such as Vladimir Mayakovsky and A. E. Kručenyx produced some of the most drastic of syntactical deviations since Rimbaud. Jakobson has spoken passionately of this generation of poets, and the linguist himself started his career as a poet of pure sound. Mayakovsky was a poet and a painter, and many of the most beautiful and drastic of pamphlets in collaboration between poets and painters, amongst themselves, and in all manner of theatrical performance, were produced at this time. Casimir Malevich's severe reduction of his art to the famous square within a square is analogous to the drastic austerity of the poets of this time, their laconism, and their fight against languors. Boris Pasternak's speedy shifts and strange metonymic dislocations, again analyzed brilliantly by Jakobson, are close to the sweeping diagonals of El Lissitsky and Vladimir Tatlin. Alexander Rodchenko's furious and infuriated photography is paralleled by the vigorous, almost scatological naturalism of Mayakovsky and his political polemics. A great deal of this revolutionary rapport was destroyed by Stalinism, in a slow, sweeping stain. By the late thirties, Mayakovsky had shot himself. The great painters were dead or assassinated or forced into hiding or renunciation. Russian film art, the great synthesis of poetry and vision, was also attacked and lost its momentum and formal intransigence.

Guillaume Apollinaire is one of the complete figures in the history of the relations of poetry and painting. His decision to take away the punctuation from his own

Above: The Dada group outside the church of Saint-Julien-le-Pauvre in Paris, photographed by Man Ray in 1921. Left to right: Jean Crotti, Asté d'Esparbès, André Breton, Jacques Rigaut, Paul Eluard, Georges Ribemont-Dessaignes, Benjamin Péret, Théodore Fraenkel, Louis Aragon, Tristan Tzara, and Philippe Soupault. Courtesy of Skira/Rizzoli International Publications, Inc.

Below: The surrealist group in 1924. Left to right: Max Morise, Roger Vitrac, Jacques Boiffard, André Breton, Paul Eluard, Pierre Naville, Giorgio de Chirico, and Philippe Soupault. Lower right: Robert Desnos (speaking) and Jacques Baron. At the typewriter: Simone Breton-Collinet. Courtesy of Skira/Rizzoli International Publications, Inc.

profoundly lyrical works led to a new richness in syntactical ambiguity. This ambiguity is like the plastic ambiguity of the cubist painters. Indeed, the parallels between Picasso and Apollinaire have been much discussed and elaborated. Apollinaire is close, moreover, to the more nearly abstract work of his friend Robert Delaunay. In his poem "The Windows," he celebrates the whole universe as a chromatic display. The effort in Robert and Sonia Delaunay to achieve a simultaneous explosion in pure color was most significant for Apollinaire, who celebrated them in prose and poetry. Like the poet Blaise Cendrars, who collaborated on huge poem-paintings with Sonia, Apollinaire was driven toward a poetics that would affirm the autonomy of form. But it never stopped him from being also a lyric poet of more conventional themes. His "calligrammes," in which the words mimic their subject matter, are perhaps paradoxically his most mimetic works and, in a sense, conventional. They are witty attempts to paint in language, but perhaps still wrapped up with the mystique of the representational. Elsewhere, in poems such as "The Windows," his subject matter is truly fractured and dislocated and in many senses comes closer to the profoundly disturbing painting of his age.

The First World War brought with it an immense desolation of all rhetorical hopes. I speak, of course, with a crude foreshortening of the historical mode. But the great Dada poets and painters invented a movement which spoke constantly of a weariness with all bombastic rhetorics. A decimated Europe and a Europe in the process of killing its children is a central theme for such disparate poets as Ezra Pound, Jean Arp, and Kurt Schwitters. The Dadaists did make of their negativity, in spite of themselves, a positive achievement. Those critics labeling, as if with a pejorative, the work of Jasper Johns, John Cage, Allan Kaprow, and others "neo-Dadaist" did not entirely appreciate the justice of the epithet. For a second catastrophe bred perhaps a second catastrophism in the arts. Surrealism itself, exiled to America in the persons of many of its party during the war, is refined into something rich and strange in American expressionistic abstraction and pop art.

13

The contribution of the Dada poets and painters methodologically is intense. Tristan Tzara made extraordinary attempts with a cut-up method of poetry that resembles the work of William Burroughs in its vigor. Jean Arp produced sculpture and poetry and poem-paintings with seemingly random forms that almost always invite a biomorphic connotation. Max Ernst wrote poetry, and his photocollages created a whole bestiary of surprises, as he used late Victorian imagery with sudden juxtapositions to create a new and possible world, much as later analytic philosophers would invent possible worlds. Francis Picabia wrote the most violent of sneering aphorisms, and his paintings of machines contain sexual and mechanistic poetries written across them that harbor witty and savage denunciations of the bourgeois.

While André Breton is too much of a pope for some, his party of surrealists yields an undying collaboration between the verbal and visual. His own novel, *Nadja*, is haunted by photographs of gloves and store fronts. Louis Aragon at this same time writes *Paysan de Paris* with its intense collagist effects of presenting billboards, menus, and tickets. The whole bourgeois novel is fractured into a new poise and pose. The defiant movies of Marcel Duchamp contain nothing but rotating puns, as if taken from the strange mechanistic plays of Raymond Roussel. Man Ray deforms the merely mimetic purposes of photography to achieve some of the most bizarre of effects in photographic collage. René Magritte establishes the uncannily arbitrary correspondence between word and image, as in his famous "This is not a pipe."

Again, the Dadaist and surrealist movements are from the beginning interdisciplinary explosions. The affair is political and philosophical and is thus not aligned in any simple way to a single art. Thus, its characteristic products are often mélanges of many textures and types, and its characteristic spokesmen participated in many arts. This does not mean that the philosophy of the movements was a great achievement. Still, the surrealists proposed a collaborative and communal venture that was a true effort at illumination. The *cadavre exquise* is perhaps the most characteristic product of such collaboration. Accidental juxtapositions are invited by the yielding of different grammatical or syntactical roles to different participants. The entire poem or poem-painting thus resembles an active ritual of brotherhood, magnanimity, and affirmation of risk. The collaborations of the surrealists influence and parallel the later collaborations of Harold Rosenberg and Willem de Kooning, Bill Berkson and Frank O'Hara, O'Hara and Michael Goldberg, Larry Rivers and Kenneth Koch. The political connotation of such acts of camaraderie should not be overlooked.

Gertrude Stein is a central example of the interpenetration of the arts in our time. A supreme psychologist, she arrived at an almost antipsychological mode of linguistic experiment. She studied with William James at Radcliffe and learned a great deal from his experiments in automatism and the "stream of consciousness." But when she renounced medicine, she, in a sense, began a long renunciation of naturalism. In a Paris bursting with painterly zeal, she attached herself to the most advanced position in art and became one of its supreme collectors and disseminators. Her own art became one of drastic dislocation and repetition. On the one hand, her repetitions are always streams that deny the very possibility of repetition. On the other hand, she is a poet of grammatical solicitude for whom an almost imageless poem may be constructed out of tropes and figures, as Jakobson reminds us, of grammar itself. Her cubist portraits rival Max Jacob's in their witty, fractured delineations of her friends. Soon, the figure almost entirely disappears. While she returns, like the neoclassical Picasso, again and again to attempt the figure, she achieves in certain poems the nearly abstract use of language, with the referential qualities held in ferocious check. She played upon *non sequitur* and the alliterative, stressing the arbitrariness of sound in every word. Her operas with Virgil Thompson and her plays are divided into almost random sequences, sometimes with a hundred acts, sometimes with a hundred characters in search of their parts. Kenneth Koch and John Ashbery learned a great deal about the power of monotony and the individual word from Stein. Her *Stanzas in Meditation* remains a powerful source book for poets and painters.

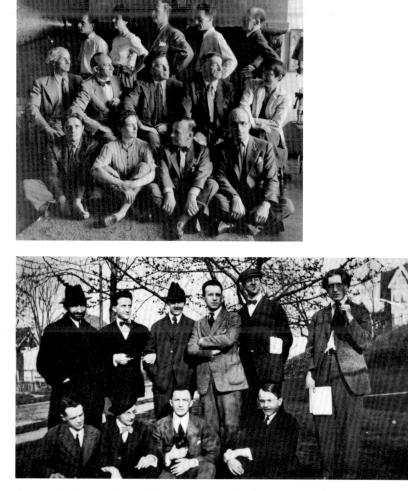

Above: "Artists in Exile," New York, c. 1942. Left to right, first row: Stanley William Hayter, Leonora Carrington, Frederick Kiesler, Kurt Seligmann. Second row: Max Ernst, Amédée Ozenfant, André Breton, Fernand Léger, Berenice Abbot. Third row: Jimmy Ernst, Peggy Guggenheim, John Ferren, Marcel Duchamp, Piet Mondrian. Courtesy of Mme Marcel Duchamp and the Philadelphia Museum of Art.

Below: The "Others" group, 1916. Left to right, front row: Alanson Hartpence, Alfred Kreymborg, William Carlos Williams, Skip Cannell. Back row: Jean Crotti, Marcel Duchamp, Walter Arensberg, Man Ray, Robert Alden Sanborn, Maxwell Bodenheim. Courtesy of the Poetry/Rare Book Collection, State University of New York at Buffalo.

William Carlos Williams and Wallace Stevens may be thought of as two polarizing forces in American poetry. Williams to some is a cubist poet, and his still lifes, like the famous wheelbarrow, fracture presentations of reality. Stevens has seemed to such a critic as Helen Vendler to lack a visual sense. I would like to reverse these usual judgments. Williams, it seems to me, is a great poet in the naturalistic mode, largely recording the movements of mind and matter in a manner somewhat between the best of the precisionists, such as Charles Sheeler and Charles Demuth, and the great photographers of the age, Alfred Stieglitz and Edward Steichen and Edward Weston. The poems of Williams are filled with a sense of complacency concerning the ground of being. He himself speaks of an almost religious conversion to security. For all that, some of his most experimental early poems speak of a love of improvisation, jazz, and abstraction. Williams was almost always in need of a world of common objects that would populate the poem. Stevens develops from the most radical of the impressionists, Monet. His poems are visions of an object that cannot be seen without the relativistic observer. While the observer always participates in Williams, there is never the extraordinary, radical uncertainty of the kind found in Stevens. Stevens attempts in his late works, too, to penetrate to a bare and supreme poem, a poem as bare as language itself, a poem of pleasure, abstract and in flux. His late philosophical meditations lead almost to the solipsistic visions of Ashbery's "Self-Portrait." Williams contributes a public art and Stevens a private poetry that becomes a public resource. Williams's intimacies are naturalistic strategies and slices.

Frank O'Hara is one of the legitimate children of Apollinaire, and he functioned as the center of the group that became known as the "New York School" of painting. But all titles are misnomers as well as names, and poets are never exactly part of a military movement. However, Kenneth Koch, John Ashbery, O'Hara, and others did indeed associate themselves with the startling principles of Willem de Kooning, Jackson Pollock, Franz Kline, and Arshile Gorky. The Americans had learned

15

from Picasso and the exiled surrealists. They had tamed the literary element of surrealism and liberated the very device of automatism so that one had an abstract painting developed from psychological and investigatory modes.

O'Hara's first poems, like Ashbery's, are both symbolist and surrealist. But both poets learned to lower the more precious parts of their diction, and both attained a collagist style, humble and dissonant at once. O'Hara wrote enormous odes dedicated to the very energies of art-making, and the smudges and smears of De Kooning aided his sense of a wind-blown poetry. His monograph on Pollock speaks for his sense of the artist as hero, and he admired Pasternak for placing Zhivago as doctor *and* poet at the center of a new novel. While Ashbery developed an insidiously private poetry that sometimes resembles a Cornell box, with its distances and toys, O'Hara produced what he regarded as "personism," a mock-movement of poetry that would restore the I-Thou (now seen, however, as a contemporary telephone conversation).

Frank O'Hara's famous poem "Why I Am Not a Painter" is a charming model of collaboration, independence, anxiety, and joy of influence:

I am not a painter, I am a poet.
Why? I think I would rather be
a painter, but I am not. Well,

For instance, Mike Goldberg
is starting a painting. I drop in.
"Sit down and have a drink" he
says. I drink; we drink. I look
up. "You have SARDINES in it."
"Yes, it needed something there."
"Oh." I go and the days go by
and I drop in again. The painting
is going on, and I go, and the days
go by. I drop in. The painting is
finished. "Where's SARDINES?"
All that's left is just
letters, "It was too much," Mike says.

But me? One day I am thinking of
a color: orange. I write a line
about orange. Pretty soon it is a
whole page of words, not lines.
Then another page. There should be
so much more, not of orange, of
words, of how terrible orange is
and life. Days go by. It is even in
prose, I am a real poet. My poem
is finished and I haven't mentioned
orange yet. It's twelve poems, I call
it ORANGES. And one day in a gallery
I see Mike's painting, called SARDINES.

This marvelous poem of 1956 may be likened by some critics to a pop art object, due to its seeming lowness of diction, its sense of almost tape-recorded speech. And yet notice the subtle stanzaic composition. The whole is formal and didactic. The painter and the poet both proceed by deletion, Picasso's "horde of destructions." Every sign is as arbitrary as the final titles. And yet the strange connection has been made: poetry has been fused with color, and a painting has been given a sign and a meaning. The poet doesn't directly approach the object: he creates an object.

In our own day, a curious phenomenon of conceptualism has resurrected the renunciations of Marcel Duchamp. Just as Duchamp seemed to elaborate an art beyond retinal fatigue and painterliness, retiring to chess and secret tableaux, so the conceptualists such as Joseph Kosuth saw in the presentation of language a fit antidote to the assemblages of the modern collagists. They proposed an analysis of art rather than a new reification. Often, these analyses, these presentations of books and documents, seemed a new kind of poetry. While Kosuth publicly scorned poetry, many of the conceptualists played with possible narrative functions in art. Laurie Anderson and others created video-performances and collage-documents that were, in a sense, phenomenological investigations of a terrain of perception that was always already both visual and linguistic. "Book art" took over from the painted canvas, and yet it is important to stress that no stylistic victory

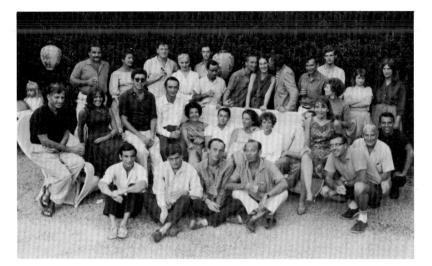

Julia Gruen's third birthday party, Water Mill, New York, 1961, photographed by John Gruen. Left to right, back row: Lisa de Kooning, Frank Perry, Eleanor Perry, John Myers, Anne Porter, Fairfield Porter, Angelo Torricini, Arthur Gold, Jane Wilson, Kenward Elmslie, Paul Brach, Jerry Porter, Nancy Ward, Katherine Porter, unidentified woman. Second row: Joe Hazan, Clarise Rivers, Kenneth Koch, Larry Rivers, Miriam Shapiro, Robert Fizdale, Jane Freilicher, Joan Ward, John Kacere, Sylvia Maizell. Front row: Steven Rivers, Bill Berkson, Frank O'Hara, Herbert Machiz, Jim Tommaney, Willem de Kooning, Alvin Novak.

was ever held. Many styles coexisted in the sixties and seventies in a pluralistic rapport, just as Picasso and Duchamp had also once coexisted. While concrete poets such as Aram Saroyan, Richard Kostelanetz, and Emmett Williams produced little visual nuggets based on language and also whole multimedia performances, other poets took from Stevens and Ashbery a conservative mask underlying a radical sense of linguistic autonomy and abstraction. The renunciation of the painterly by many of the conceptualists began to seem, even to some of themselves, a puritanical regression. Thus, in Mary Douglass's terms, a less pure but more dangerous art recommenced, and less pure and more dangerous marriages of arts.

The idea of the *Gesamtkunstwerk* or total work of art has been resurrected in performance art. Roselee Goldberg in her new book, *Performance*, has documented the kinetic side of futurism and surrealism and the Bauhaus. For many artists, such as Lucio Pozzi, the genres had to be dissolved again as Borges dissolved story and essay form in a new antiform with Kafkaesque resonances. Pozzi gave a series of theatrical events in which nonsense language was spoken, billiard players dressed in grey velvet paraded in silence, and strange juxtapositions of slides were shown to a baffled audience. Robert Wilson's opera played upon surrealistic associationalism. A bed rose for an extended period of time as an entire scene. The stage was split apart physically by bars of a cage. Philip Glass's repetitive musical minimalism was collaged against a poem that was a litany of radio names and times and speakers. Wilson, Pozzi, and others are resurrecting the kind of savage cabaret that exploded in Dada times and with the strangest of the Weimar theatrical geniuses, Bertolt Brecht and Kurt Weil. Here, painting and poetry find their natural situational goal. The theater has seemed horrifyingly public and naturalistic to the more ivory-tower symbolists, but here it becomes something detached and private as a sacrifice. Poetry becomes libretto and the visual becomes contextual. The architectonic goal is reached, and Richard Wagner is seen as poet-composer-entrepreneur, as a demiurgic precursor of all contemporary syntheses.

Some Contemporaries

The poets and painters represented here are linked in every possible, even canonic, way. Some have influenced each other through anxiety, and some through joy. Some have purposely stood distinct from each other but kept, therefore, a linkage through defiant purism. There are in some true collaboration and on-going works of interdisciplinary zeal. Some have merely decorated each other's main works. Some have recognized the improbable fate of complete congruence. That is, some have recognized that their poem was always already a painting and that their painting was always already a poem. "The more angels the more room," and the room that is afforded by painters and poets marrying, as it were, is enormous. The poets discover that the page is a site for visual redistribution; the painters discover the canvas as a page for semiotic dislocation and estrangements unknown heretofore. Both are involved in what Michael Riffaterre has called the first reading of mimesis and the second of semiosis, that is, the procedure from representation to formal significance.[4] Both poets and painters are involved with the palpabilities of a material underlined dominantly by and of and through itself, in Jakobson's sense. All attempt to erupt into history for the first time or as if for the first time, as Kristeva has noted of the vital categories of semantic arts.[5] All as critics stand vigilantly to revise themselves.

In the history of interdisciplinary studies, surely John Cage would receive a special chapter. He is a seminal force not only in music, but in poetry, painting, sculpture, theater—in a sense, wherever his particular species of wise passivity has affected creative thought. He is certainly more than a composer, though one should never deprecate the extraordinary music that he has indeed composed. Like Edgar Varèse, his alarming precursor, he has experimented with every timbre, every nuance, every mechanism of the every day. While he is best known for the provocation that was his famous "silent" piece, a piece filled up as it were with the music of everyday life, he has written in a multitude of modes, for example, the chaste and simple melodies for violin of the fifties. As a poet, he is equally capable of many modes. His storytelling is legendary for its humor. The record

entitled *Indeterminacy* is filled with both autobiographical and Zen wit, as the author prettily fills up time by speeding up or slowing down his stories. He also loves to write in "mesostics," a form of acrostics revealing at once his love of visual and verbal puzzles. These puzzles are, however, as naked as his silent pieces. They accept the arbitrary aspects of language and revel in them. He has gone through *Finnegans Wake* searching for the name of the author—finding the name, we might say, rather than searching, though he is indeed an indefatigable searcher for mushrooms and for other particularities. As the proper name stands in his poems, bright and fixed, it seems almost comically exact, another object in the Duchampian antitradition.

John Cage's relationship with Jasper Johns and Robert Rauschenberg is both personal and methodological. Cage seems to have given to both artists an exhilarating sense of the possibilities of chance. Even more, he has insisted upon a humiliated diction in materials and operations. Johns is an extremely humble artist for all his meticulous care, or due to his care. His maps, flags, and targets are part of a Wordsworthian project to reduce the fanciful and too luxurious rhetoric of the expressionists. Rauschenberg perhaps has more of Cage's buoyancy and humor. His famous sculpture-painting of a goat encircled by a tire is a poignant attempt to bring the music of everyday life back into art and also to dissolve conventions.

Johns has an art that seems much less theatrical than Rauschenberg's or Cage's. With Merce Cunningham, all have participated in a vernacular style in the most important dances of our century. Rauschenberg's sets were always the most exuberant and lacy, a tirade against reduction. Johns's intimacy speaks of an almost intransigent melancholy. Of course, both Johns and Rauschenberg have been involved philosophically in a project that rivals Cage's in its antipathy to mimetic conventions. Rather than mimicking thunderstorms, Cage invites them in on tape in a provocative but naturalistic gesture. Johns has always rigorously investigated the limits of illusion. His life's work is like a Wittgensteinian album of aphorisms

concerning representation and its problematics Rauschenberg has explosively melted the boundaries of illusion and reality in theatrical performances, events, dances, and combines. The art historian Leo Steinberg has credited Rauschenberg with a new sense of antiperspective, one that abolishes any easy rectilinearity. Perhaps we may say that Cage's experiments with chance operations and his new language experiments in long vowel chanting are likewise breakdowns of syntactical perspectivism. Johns shows his preference always "for disastrous relationships," never more dramatically perhaps than when he changed the positivistic color scheme of Buckminster Fuller's World Map to a strangely arbitrary one. In Cage, Rauschenberg, and Johns there is a mistrust of intention if it isolates itself from the pleasures of serendipity.

In a sense, they are all heroes of the tradition of collaboration, but in the subtlest directions. Cage has often composed music for Cunningham without necessarily illustrating or witnessing the dance. As the dance happens, the music simply falls to one side, as for instance a plucked cactus amplified. Rauschenberg's elaborate settings need not have any simple, mimetic relation to the dance; indeed they fly apart wonderfully from it. Johns is known for the severe reduction of his grey-to-white costumes. Johns's collaborations with the poets of his generation, such as Frank O'Hara, have been as severe and introspective as a modern Odilon Redon. His book with Samuel Beckett, *Foirades*, presents an encyclopedic tribute to frustration and empathy: brick walls and labyrinthine dashes. Perhaps only Rauschenberg, in his *Inferno* series, has achieved a more sullen sense of one art's relatedness to another.

Barbara Guest is a very fine and even rarefied poet of the so-called "New York School." Her poems became quite well known through the Donald Allen anthology entitled *New American Poetry*. There is in her work, as in the painters she has chosen to write about here, Faye Lansner and Robert Fabian, a revaluation of surrealism. Here the apocalyptics of surrealism have become something muted and urbane. This does not mean a reduction of all color, however, and there are rich texturings of language with finesse of juxtaposition and syntactical deviations. Just as Lansner may suddenly explode in a bright and "symbolic" red, so Guest may suddenly burst a grammatical norm. But the art of Guest remains beautifully lyrical, in Jakobson's sense, with a tilting toward the first person and even present tense, though there is a ubiquitous acceptance of nostalgia. In Fabian's work, one feels the presence of Kurt Schwitters and the redemption of the detritus of the every day. Lansner involves herself in the recovery of the figure— placing it in an abstract ground and thus profoundly uprooting it. Guest's *I* or *We* also seems curiously distinct and deracinated through all themes of dependency and doubt: "We leave our usual motors/To rely on this arm to guide us." None of these artists breaks into a false hilarity, none is deadpan in solemnity. Fabian has spoken of the need for a synthesis of abstraction and realism, and one might find in these three a quiet and persistent attempt to yield this problematic unity.

The critic Valentin Tatransky has spoken of the materialism of Rosemary Mayer's work. Perhaps it is not too late to rehabilitate materialism as a way of thinking about much that is, indeed, seemingly of ideal value in the works of Bernadette Mayer, Rudy Burckhardt, and Rosemary Mayer. I do not agree with Tatransky that it is a "materialism of the child" and a matter of gift-giving, much though I am attracted to any theory that may stress the theme of reparation in artistic guilt. But that way lies a drastic psychologistic attitude on the part of the critic. No, the links between poet, painter, photographer, and film maker are more direct though seemingly concealed.

It is again the linguist Jakobson who provides the key to a rigorous understanding of this materialism.[6] He has said that every message may be an interplay between a sender, an audience, a code, a material contact, a world, and the artistic form itself. He has described the "poetic" as an underlining of the palpability of the form. For Bernadette Mayer, the palpability of the English language is dominantly stressed beyond all reference to the poet or the addressee. Even in the most lavish of Rosemary Mayer's production, there is an underlining, not of the potlatch or ritualistic sense of art, but of the material display itself in all autotelic chromaticism. Burckhardt's

bewilderingly stripped street scenes are not De Chirico echoes of an anxiety as much as they are romances of photographic art. I do not want to speak as an old-fashioned purist but, like Jakobson, of the dominantly materialistic, nonreferential quality of all three artists.

Ron Padgett is one of the most innovative poets of his generation. He has been continually involved in the visual arts and has collaborated with Jim Dine on a wonderful series of lithographs. Here the poet contributed childlike drawings and enormously exaggerated epithets. He kept a journal of his collaboration, and it is a hilarious, deadpan record of the struggles to reach an accord. It is a kind of prose parody of Frank O'Hara's trials and tricks in "Why I Am Not a Painter." Padgett's most beautiful poem, "Sky," is suddenly interrupted by an actual printed bar of blue. The poem resembles those legendary pictures by Picasso, drawn while the painter was composing a poem but had forgotten everything about a word except its conjured image. Bizarrely, in Padgett, this bit of blue paper even increases the distance between signifier and signified. We feel this arbitrariness in the art of George Schneeman. While his portraits are filled with particularity, and even poignant particularity, they use a quattrocento style that flies away from the lower East Side. The naked figures or funky phantoms are carefully drawn in a fashion reminiscent of a Piero della Francesca. Here everything rises against psychologism and chiaroscuro. Padgett is similarly close to Patricia Padgett, who uses watercolor without any overtly sentimental sense of fluidity or instantaneity of wash. In his stories and poems, Padgett has despised and mocked traditional narrative. Schneeman, in what may at first seem a decidedly conventional art, is also lampooning the conventions. All lampooning involves a form of homage both happy and unhappy, and so the poet and artist are rich parodists in a new pop vein.

Padgett's own poetry may be usefully likened to the pop art of Roy Lichtenstein and Andy Warhol. His poems seem to resent the more florid excesses of the first generation of New York School poets. They are constant deflationary exercises. In his cartoon-poems, Nancy and Sluggo slide by in a funnily fractured history of nonsense.

A hand presenting a page filled with seven cartoon clouds is followed by another, and utter, *non sequitur*. The *non sequitur* may be of a child Nancy playing, for instance but the art is not merely *enfantine*. It is the rigorous and even sneering art of an adult who knows how to regress for the sake of mastery. In this case, Padgett achieves mastery over encrusted forms. The comic strip is shown to have lyrical possibilities that have been overlooked for no reason.

Padgett in this sense "estranges" everything, as the Russian formalists said the artist and poet must do. The comic strip is rendered strange to us in a genre explosion. The sonnet form is taken and twisted by Padgett until every line merely whimpers, "There is nothing in that drawer." But here repetition is steely and not whining. The sonnet of fourteen repeated lines fulfills almost every classical notion of introduction, rhyme, closure. It has that palpable equivalence which Jakobson sees at the heart of poetry. Each line is a metaphor for every other line. Padgett's constant sense of the mystery of the materiality of language is seen in these lines from the hilarious poem "The Giraffe":

> The 2 f's
> in giraffe
> are like
> 2 giraffes
> running through
> the word giraffe

Patricia Padgett's watercolors are charming analogues to Ron Padgett's work, and they are more than analogues. She presents expertly the nuances of everyday life—a bowl of cereal, a rainbow curtain, a shirt—with clarity and wit. Her love of color is seen everywhere, in the tiny changes of green and beige, for example, always rendered with modesty. Her skepticism concerning abstraction and bombast matches Padgett's, as when she sets a drifting series of purple squares in air above a quiet landscape.

Bill Berkson and Philip Guston offer very interesting parallels. One senses in both the early capacity for a nuanced and delicate abstraction. In Berkson's early poems we have the painterly:

. . . The tepees shake in the blast like roosters
at dawn. Everything is special to them,
the colorful ones.

"October"

Now trouble comes between the forest's selves,
And smoke spreads to pools in which we stroke
Our several smirks, but the accident will not
 happen
For someone has stolen the apples

"Russian New Year"

While, in much of the early poetry, there are sudden
urbanities, as in the poetry of O'Hara, and an insistence
on humor and attention to objects, a kind of abstract
collage is usually created with the elements. This is not
too far from the abstract systems of Guston's early and
delicate *Drawing No. 4*, 1950, in which objectlike shapes
almost create an objective mélange. But the lines float
slowly out of focus; the edges are loosened.

In the late work of both of these fabricators of new
design, a quiet revolution has occurred. In Guston, there
is the wrenching reappearance of the almost caricatured
figure. Hooded figures slink past in an obdurately heavy,
again almost lampooning, charcoaly thickness. A clock
appears with the slowest of movements in a childlike
and persistent, humorous hand. Berkson has also brought
his poetic "drawing" to caricature in "Call It Goofus":

Foot still, and nothing to go,
or the Japanese see ghosts,
each man in his own way walking.
I go see an old friend become
a new husband, a student girl
draws something looks like wood, her
friends call it ugly, I buy it, she
gives it to me—
 what's the difference?
I see maple trees on Maple Avenue,
Ravel sit down "his arms like matchsticks". . .
Know who I was?
That fellow sitting here thinking,
minutes ago.

In both Guston and Berkson there has been a brave
sacrifice. Many critics who are in love with pathos
decried in Guston's work the sudden figuration with its
grotesque simplicity. They despised the cartoonlike
presentation, its seeming acceptance of popular culture,
and they were certainly uneasy with the many political
connotations of the hooded figures. But Berkson and
Guston are part of a group that has come to despise the
old pieties. If avant-garde art stood for a long time against
narrative, there is also something refreshing in trying to
recapture some of the strengths of narrative. Both Guston
and Berkson have accepted the simple directedness of the
arrow of narrative and figuration. Their bold bathos is
still a kind of surrealism, a surrealism of the every day. It
is still what Walter Benjamin called for in his essay on
André Breton: "profane illumination." Guston and
Berkson have profaned their own past art, in a sense, to
arrive at a new illumination. Of course, the past art is still
glorious and delicate in its waverings and imprecisions,
but the new art is also fertile in a more fixed form.

Lynn O'Hare's work is jubilant in its flatness. It is a
true analogue to Bill Berkson's bright, insouciant, and
syncopated poems. In watercolors, she is as strong in her
effects as poster paint. In poster paint, she yields some of
the effects of Japanese wood-block prints. The humor in
her work is remorseless: a foot intrudes upon a
hallucinatory carpet. We are looking down at ourselves,
but we, the spectators, are also given a glimpse of a part
taken not for the whole but for the part. Adrian Stokes
has talked a lot about this feature of the psychoanalytics
of art and how, like infants, we project or incorporate
parts of the body intuited as good or evil.[7] In O'Hare's
striped and colorful world, these parts are offered as
certain good. The world may be hidden by Venetian
blinds, but even those blinds are colorful composers of the
light.

James Schuyler is one of the most important
painterly poets in America. On the one hand, he is a very
patient empiricist, carefully picking details, noting all
down in a diary of mundane concerns, forgetting
nothing, paying attention. He is thus linked with the
patient, empiricist painter Fairfield Porter, a critic of

great stature who insisted on the abstract quality of such particularity. In Porter's own sense, the paint and not the referent counted. This is true of Schuyler's verbal landscapes and of the scapes of Anne Dunn and Jane Freilicher. John Ashbery has spoken of the "frugality of means" in Anne Dunn's work. This frugality itself is a moral and aesthetic topic. But both Freilicher and Dunn permit themselves extraordinary lyrical passages of color, and these intensities remind one of the more sustained passages in Schuyler. Ashbery has also spoken of Dunn's "chill and 'commercial' colors." Schuyler too will suddenly use words that come from business, popular culture, sexual slang. His poetry is sometimes a whirlwind of brand names with a chilling textural quality. Ashbery suggests a reason for this when he points out the "utilitarian" nature of ink. Language is primarily used by men for pragmatic purposes, and Schuyler makes a witty play on pragmatics by using and abusing the most pragmatic of dictions. Freilicher exalts the common scene about her, as though it were as glamorous as a palace. Her outdoor light is sustained somehow even in the studio. Her precise spontaneities, in the tradition of Bonnard and Vuillard, link her to Schuyler's poetry. It is as if some of his poems were written in her bright pastels, the most vulnerable medium.

The following "Song" by Schuyler shows his constant play on the correspondence of language and vision:

The light lies layered in the leaves.
Trees, and trees, more trees.
A cloud boy brings the evening paper:
The Evening Sun. It sets.
Not sharply or at once
a stately progress down the sky
(it's gilt and pink and faintly green)
above, beyond, behind the evening leaves
of trees. Traffic sounds and
bells resound in silver clangs
the hour, a tune, my friend
Pierrot. The violet hour:
the grass is violent green.
A weeping beech is gray,

a copper beech is copper red.
Tennis nets hang
unused in unused stillness.
A car starts up and
whispers into what will soon be night.
A tennis ball is served.
A horse fly vanishes.
A smoking cigarette.
A day (so many and so few)
dies down a hardened sky
and leaves are lap-held notebook leaves
discriminated barely
in light no longer layered.

Let us examine this poem a bit closely. First, note its constant insistence on the present tense. What is extraordinary is its sense of an elegy writing itself. By the time one arrives at the final dark light, one is hardly aware that so much controlled observation has gone on. The first line is filled with alliteration. It thus quietly controls the inauguration of its own form. The diaphanous sense of light is yielded through the phrase "a cloud boy." The parenthesis and the light enjambment of "faintly/of trees" produces both a flow and hesitation. There is a parody of Eliot in the "violet hour." In Eliot, the phrase is purgatorial, and here insistently naturalistic and deflated. As in Freilicher and Dunn, there is a mimesis that refuses to be undermined. The tennis nets and the tennis ball are all noted. But the end of the poem is as refulgent as the most colorful Dunn or Freilicher, and it even reminds one of Claude Lévi-Strauss's chromatic elegy on board ship in *Tristes Tropiques*. The day is not noted by a mere empiricist in Schuyler, but by the Lucretian poet, who knows wearily that this is the mild and final pleasure, the pleasure of the lack of finality, the pleasure of an unredeemed and even possibly unredeemable world. The sky and the leaves turn into a book, an almost moral book of Mallarméan lack of morality: "and leaves are lap-held notebook leaves." The landscape is a book, as in one of the earliest senses of landscape. All is semiosis. The poet, like the painter, tries to discriminate in the dark. The painting of the night sky is, as it were, the horizon of the possible marriage of poetry and painting. Just as the poet stops

with the last illegibility of night, so the painter must stop in a world without light. This little poem is amazing in its circularity and its advances. It lacks all complacency. It returns to the alliterations of layered light, but in a new and even horrifying sense. "No longer layered." The poet's very poem takes up the time in which his subject vanishes. In a sense, Schuyler's art, for all its detail, is very temporal and is more of a performance piece than a landscape. But it is as if a performance piece were enacted with all the materials of Dunn's and Freilicher's most poignantly detailed scapes. The poem is indeed a "song," a lyrical interpolation far from all reductive prose discursiveness. *The Evening Sun* and the evening sun are too and two very different things in a world of poignant puns.

Kenneth Koch is one of America's consistently underrated but utterly influential poet-teachers. His comic poetry is often likened to Byron or Ariosto but is usually somehow devalued for its comical lavishness. Actually, his flamboyant affirmations are in the spirit of the materialism spoken of in relation to Mayer and Burckhardt. Like Gertrude Stein, Koch has an uncanny ability to separate words and weigh them. His earliest poems of radical quality are abstract expressionist cadenzas in which hardly any *sequitur* survives of normal quality. These cadenzas of the early fifties might be regarded as the central quarry of forms for all the later Koch, despite all neoclassical or Italianate revisionism. Although they have much of Rivers's flashing disdain and his appetite for dislocation, they resemble De Kooning's wildest versions and visions even more. Rivers learned from De Kooning as Koch learned from Stein and De Kooning. Later, Koch, like Rivers and Dine, went through a period of insistent clarity. He associated this period with the directness of love. But it was also a deflating, parodistic, and even troubled directness, the kind one associates with Dine's frank devotion to the actual in a mimesis that challenges all representation by such strategies as putting a "real" sink on a canvas with painted shadows. Koch's seemingly straightest poems always have a campy subterfuge. They challenge the reader in matters of tone. As a matter of fact, this challenge may be its comical political intransigence, for

all its aestheticising *topoi*. The persona of the poet would be forced to deny this, of course. Grooms and Koch share this constant denial of any older, pietistic subject matter, but they both accept the city and the cityscape and the city vision as possible *catalogues raisonnés* for derangement. Grooms creates a miniature city, just as Koch delights in creating epic and comic-epic visions. In one of the happiest collaborations in the past decades, Grooms created sets for the wild-animal plays of Koch's early period. The entire stage split open to reveal the world as an orange. Only Koch and Grooms could do this.

Rivers, too, has collaborated wildly and originally with Koch. Koch predicted conceptual art in his poem "The Artist," in which one gradually sees the grotesque advances of art as an impossible travesty of a career of phantasmagoric self-delusion. The artist begins mildly enough with certain sculptural projects, but these fields with a few boards are finally replaced by gigantic commissions which will block rivers for centuries. The artist concludes by ordering tons of blue paint for a work on the ocean. Koch mistrusts too infantile displays of mimesis in his poetry of surface, but, for all that, he predicts Christo and the great mile-long curtains and the earth-workers because of his zest for all impossible celebrations. Rivers, in such collages as *The Russian Revolution*, also yields to this encyclopedic lack of *ressentiments*. Dine, in his famous tool series, reiterates an almost fetishistic concern for the tools of everyday life. These tools are again and again transformed into dreamlike analogues of emotional energy. Dine may draw a braid hanging in space, but the braid is turned into a surreal object of Eros. Grooms, Rivers, Dine, and Koch are the great comic poet-painters of our age.

It is interesting to see how painting itself plays a central role as style and topic in Koch's comic achievement. He uses an eidetic imagery that is reminiscent of Rimbaud, even where the stanza is Yeatsian: "I set forth one misted white day of June." Here there is more of Rimbaud's gorgeous poem "Fleurs" from *Les Illuminations* than there is of the Yeats of the stanza form as it proceeds. Color itself is hypostatized into a force: "By silver's eminent lights!" Natural light and *jeux d'artifice* meet and hardly mingle: "The light on a bright

night . . . Lovely are fireworks . . ." Even commercial tags are part of this homage to light: "The Green Can Sighs have fallen in love." In a very direct way, Koch draws a spring walk. "Let's make music/(I hear the cats/Purply beautiful/Like hallways in summer/Made of snowing rubber . . .) Oh see the arch ruby/Of this late March sky . . . Let's take a walk." Here again, the poem ends canonically with light as a visionary climax: "O blind. With this (love) let's walk/Into the first/Rivers of morning as you are seen/To be bathed in a light white light/Come on" The poem concludes with the punctuationless ecstasy of Apollinaire. The words are in a low, Wordsworthian demotic; the sentiment is high and undiminished. In another poem, Koch's very self turns into pigment: "I am the color blue, on a board in the room." Synaesthesia is central as a device of wholeness, not just dislocation: "In the blue hubbub . . ."

Perhaps one of the most moving images of the marriage of poetry and painting is in Koch's "Fresh Air." The poet finds that air itself is an art student and apotheosizes it as such. When he pictures the apocalyptic demise of fatuous rigors and absurd dogmas, he pictures a "great expanse of green" beneath which the rest of us will drown. Color redeems and color destroys. Matisse-like liberation of color for its own sake produces an effect of ritual celebration and sacrifice. A certain sense has been sacrificed, and an abounding, explosive, almost nonsensical, witty energy survives.

Koch, like Rivers and Dine, insists on popular culture. Dick Tracy appears as strongly as *and* as significantly underlined *with* and *for* association as Achilles. Just as Rivers used Camel cigarette advertisements and French money as an antidote to personalistic excesses in expressionism, so Koch uses a furiously embroidered kitsch vocabulary in his famous "You Were Wearing." The figures of the boy and girl are as cardboard or *papier-mâché* as anything in Grooms. They are as inspiredly insipid as any two-dimensional Alex Katz. The obsessive detailing reminds one of the "good draughtsmanship" in Dine and Rivers that tried to parody the masters. The ending, with its tone of sudden, if hilariously inappropriate, historical association, is a truly American note.

You were wearing your Edgar Allan Poe printed
 cotton blouse.
In each divided up square of the blouse was a
 picture of Edgar Allan Poe.
Your hair was blonde and you were cute. You asked
 me, "Do most boys think that most girls are
 bad?"
I smelled the mould of your seaside resort hotel
 bedroom on your hair held in place by a John
 Greenleaf Whittier clip.
"No," I said, "it's girls who think that boys are bad."
 Then we read *Snowbound* together

 · · ·

In the yard across the street we saw a snowman
 holding a garbage can lid smashed into a
 likeness of the mad English king, George the
 Third.

It is not surprising that Koch, in his famous pedagogical formulae for children, insists on the central place of color in language. He is also one of the steely structural innovators of contemporary language.

John Perreault is a fine example of the poet-critic, a man who, with an energy reminiscent of the most explosive of the surrealists, marries all disciplines in an effort to dissolve genre distinctions. Perreault created an elegant, almost delicate, pop poetry in the sixties, with such clear diction as: "Why is everything I do in my life like a boomerang?/I throw the paper airplane out the window/and the wind sends it back./I spit against the wind." Interestingly, when he later became vitally involved in street sequences and conceptual events, these poems were like the scripts for such events. Instead of the title, "Mystery and Melancholy of a Street," we are actually given the street as newly found, theatrical non-site. The impersonality Perreault strives for, moreover, always belies a charming personalism: "Inside my life they find a weapon/and in my lungs a tree./And in my heart/they discover a mirror./But they can't find me." In this, the most musical and childlike of his masteries, he announces his demotic program of withdrawal and parodical presence. In Ira Joel Haber's haunted houses

and complete scapes we find this poem almost materially re-presented. Joseph Cornell's precious intimacies have become something cartoonish and horrifying. Sylvia Sleigh's nudes present the poet as vividly and directly as an event on a street. But the dreamy defensiveness is not lost. In one portrait, the poet is repeated three times, as in an obsessed investigation of self, but with no easy marks of such obsession. Value is not besmirched, as in Warhol's repeated Mona Lisa experiment, but any easy sense of finding the subject is despoiled. Sleigh's new valuation of realism is like the demotic in Haber's materials and the everyday diction of Perreault. All three present organized structures of high obsessive and obsessed unity. The smiling figures of Sleigh's group scenes are slightly insidious mirrors masking inveterate weapons. Haber's mistrusts are more explicit. Perreault's own criticism shrewdly analyzes and affirms both modes.

Carter Ratcliff is one of the most abstract and painterly of poets in the last wave of New York School poetry. He has developed a beautifully intelligent body of art criticism in affirming abstract painting. His selection of Willem de Kooning and Rafael Ferrer speaks for a sensibility that is never eclectic but is never smugly centered either. In these seemingly disparate artists, he admires the ability to examine the limits of style. On one occasion he has spoken of the great expressionist and the strange neoprimitivist (though this is not pejorative) as "energy areas."[8] In both Ferrer and De Kooning, what is admired is not a simple product but a long investigatory process. The long-lined Ratcliff poems often seem like this endless experiment. Ratcliff has spoken of the "big banners" of both artists' forms of celebration. He has written, of Ferrer, that a strange sublime is attempted. Certainly the poet Ratcliff attempts again and again to reach a poetic scale that will permit a new American sublime. There is, of course, the tradition of American luminism. But there is also the equally sublime tradition of American darkness. Ratcliff, Ferrer, and De Kooning are linked by their opacities.

Peter Schjeldahl has created a varied poetic career. On the one hand, he has written many nervous, colloquial poems that are related to O'Hara's empirical "I do this, I do that." Very late in this still relatively new career, the poet produced a strange notebook of dreams. Each dream was dryly noted, but the dreams themselves were so elaborate, so gorgeous, so multifaceted that the clinical recital was undercut by the plots themselves. The dreams heralded a departure from the breezy tone of the early urbanities. Also, while the poet began to practice more and more as an art critic, the poems became fewer and acquired a savage prose elegance. This new style, a style that is related to Koch's comic pedagogical treatises, is foreshadowed in the extraordinary polemical blast "To the National Arts Council." This poem is as sharp as any portrait by Alex Katz, as explosive in its fury as the most painterly cadenza of the poet's "favorite," John Seery. It is also an *objet trouvé*, since the entire poem is a witty framing device around a seeming "letter." Schjeldahl is an earnest art critic, as his recent revaluation of Mark Rothko and Edvard Munch shows.[9] He has tried to revitalize our sense of the sublime in Rothko, a sense recently much impugned. He has stood, with Katz and Seery, almost conservatively for the forces of synthesis of mimesis and antimimesis, of emotion and constructivist impersonality. In Munch he finds a rich predecessor, a man who painted women in ecstasy without contempt, a painter too easily deprecated for expressionism. While he himself cannot directly subscribe to Rothko's version of the sublime, he refuses to underrate it as a program and a painterly ethos.

Fairfield Porter used to speak of Alex Katz as our greatest painter. He admired the sharpness of the designs, the steely prints above all, and the Roman public scale. One is dazzled by the early wit of Katz in his "detective story" paintings in which a cartoonlike figure is framed by Matissean color. In his steel cutouts, he redeemed a great deal of Americana by shrewdest parody. In his sketches and watercolors, he is as softened and sensuous as Pierre Bonnard, but in his late versions of Hampton parties and group picnics and individual faces, he is as sharp as a hard-edge abstractionist. His figures are unblinking. His two-dimensionalism is resolute. He is capable of the grandest color explosions, as in the by-now-famous scarf in the poet Anne Waldman's portrait. One of the most public of his acts was an immense series

of faces on a Forty-Second-Street billboard. This encyclopedia of an unbattered realism stood on top of the scene like a hymn to difference and order.

Seery's art seems to be the least literary of matters. Schjeldahl has even apologized for its apparently "mindless" qualities. But liberated color is, in many ways, from Rimbaud on, a literary tradition. This explosive scape is a vision—a materialist vision. The victory for color is like a victory for Eros. The large passages of red, green, and blue remind one, by the way, of Arp and Miró in their childlike pooling. Just as Schjeldahl's poems insist on the autotelic qualities of language, so Seery's painting reflects upon self-reflectiveness. Self-reflection is thus both a topic of pathos and a joyful style. Seery's art refutes nothing; it is an art of pluralistic acceptance against all blindnesses. It reminds us of William James, who insisted that Jack's vision of the beloved Jill was truer than Jill passing an indifferent audience.

Anne Waldman is at once a poet and a pedagogue and a performance artist, in a sense. Her poems are often chanted repetitions. They insist on her personality but even more on the very personality of language. One might say along with the too mystical Heidegger, "What speaks in this poem? Language speaks in the poem." Heidegger is perhaps too reductive, like the formalists who would reduce all to a zero degree. Waldman, like Joe Brainard and Yvonne Jacquette, is lavish *and* careful. Her propositions are constant demarcations as they are constant expansions. Like Walt Whitman, Waldman is a poet of Democratic Vistas. Brainard remembers, in one of his most famous prose forms, all that has occurred to him to the last syllable of unrecorded trivia. Jacquette is patient with the most minute of scenes glimpsed from the high and democratic omniscience of a plane. These artists and poets resemble each other in their common heritage of a Whitmanian mania for a scribal record. They work, each of them, with a wonderful sense of foreshortening and découpage and composition, but beyond the niceties of balance and unity is the unifying theme of recall. They each participate in the American utopianism of the vista. Brainard uses his personal life to gain a sense of infinity and the comic sublime. Jacquette reaches a stippled glory in the dark half-troubled by commercial signs, rare as

unguents. Waldman preaches a kind of eclectic Buddhism learned from Allen Ginsberg and Gary Snyder tempered by the language experiments of the more cubist poet Ted Berrigan. Jacquette's is a mute performance. Brainard is reticent even as he yields all details. I have spoken mostly of Brainard as a verbal artist. In his paintings, he has established vistas learned from Rauschenberg: endless flowers, infinite grasses, combines of commercial icons. His early collages were brilliant parodies of Rauschenberg, but they could not stem the complete theme of American affirmation. In his late paintings, he has established a quiet pastoralism, in certain senses, a possible antidote to all yea-saying. Waldman's most far-reaching analysis of her own sentiments and sensibility is possibly her prose and collaged journals in which the poet uses factuality and lyric interruptions as a way of defeating a too delusive tribalism. Her journals are a form beyond mere repetition.

Peter Frank is a poet influenced by the strangest of the surrealists, Vicente Huidobro, whom he has translated. His gentle whimsy and almost violent eclecticism represent a defense and weapon. He is a formalist with a shrewd and careful sense of his generation. His attention to self-reflective books culminated in the most vigorous section of *Documenta 6* in 1978 in Kassel, Germany. Ted Stamm contributed to that section in his magical and slightly maniacal books. The artist created an obsessive series of collaborations in which he rendered one book and had visitors follow a rule system in an elaborately symmetrical corresponding book. The results were not impersonal, as the artist seems to have intended, but a comical catalogue of the differences that constitute "man as a sign," in Charles Peirce's terminology. Stamm is one of our most inventive new abstract painters, and he has recently produced the finest cruciformalities in shaped canvas. Like Frank, he has advanced beyond mere irony.

Tobi Zausner's work is filled with exuberance. Her oils are rendered (through readings of Vasari and others) with as many as twenty layers for luminosity. She has drawn the poet Peter Frank elsewhere with a flaming teacup matching, in a wonderful visual pun, his flaming

Footnotes

red hair. I regard her works as more religious than
surrealist, and she does have antiwar themes and themes
of mythology that emphasize drastic transformation. I
admire the almost parodistic strength of her thirties
figure, almost Bogart-like, lurching down a film-set
pavement. Peter Frank is a poet who accepts this
idiosyncratic use of the concrete and the oneiric.

Once, in a dream, I requested an insight from my
mother as to the practice of poetry in Paradise. In the
dream, I was scrutinizing the surface of a lake. The poem
of Paradise would presumably float to the surface very
much the way answers floated to the top of a toy mystic
ball sold in my childhood for use at parties. Straining
with some anxiety to glimpse the poem, I was surprised
and frightened when a series of colored lines floated to
the top of the lake and revealed that poetry may be a
form of painting. This dream seems a parable of the
union of art and language.

1. Roman Jakobson, "Poetry of Grammar and the Grammar of
Poetry," *Lingua* 21 (1968): 597-609.

2. Roman Jakobson and Linda R. Waugh, *The Sound Shape of
Language* (Bloomington: Indiana University Press, 1979).

3. For the purposes of a show of contemporary artists, to trace a
background from antiquity to modernism is an impossible task.
Two of the most beautiful studies of the relations of the arts in
the Middle Ages and Renaissance are Rensselaer Lee's *Ut
Pictura Poesis: The Humanistic Theory of Painting* (New York:
W. W. Norton & Co., 1967) and Meyer Schapiro's *Words and
Pictures: On the Literal and the Symbolic in the Illustrations of a
Text* (Hawthorne, New York: Mouton Publications, 1973). The
first is an important introduction to the humanistic tradition
that has associated the verbal and visual arts. The latter is a
most suggestive semiotic study on the variety of paths by
which artists have developed significant correspondences
between linguistic and visual signs. One of Schapiro's most
beautiful sentences conjures up the intricate rapport between
grammar and perspective: "Just as a novel written in the third
person narrative form can be as revealing of a self as the novel
written in the first person which maintains a note of intimate,
confiding self-disclosure and brings the narrator close to the
reader, so in a painting the profile may carry a subtle
expression of a speaking self." This tactful, accurate, and
always passionate analysis of word and picture leads to the
most practical sense of poetry's painterliness and art's
propositional qualities.

4. Michael Riffaterre, *The Semiotics of Poetry* (Bloomington:
Indiana University Press, 1978).

5. Julia Kristeva, in A. J. Greimas, *Essais de sémiotique poétique*
(Paris: Librairie Larousse, 1972).

6. Roman Jakobson, *Questions de poétique* (Paris: Editions du
Seuil, 1973) and "Linguistics and Poetics," *Style in Language*
(Cambridge, Mass.: Massachusetts Institute of Technology,
1960), pp. 350-377.

7. Adrian Stokes, *The Critical Writings*, ed. Lawrence Gowing
(New York: Thames and Hudson, 1978).

8. Carter Ratcliff, in a telephone interview with the author,
1979.

9. Peter Schjeldahl, "Munch: The Missing Master," *Art in
America* 67 (May-June 1979): 80-95 and "Rothko and Belief,"
Art in America 67 (March-April 1979): 78-85.

Bibliography

Apollinaire, Guillaume. *Selected Poems*. Translated by Roger Shattuck. New York: New Directions Publishing Corporation, n d

_____. *Art Criticism*. Edited by Leroy Breunig. New York: Viking Press,1972.

Allen, Donald Merriam, ed. *The New American Poetry*. New York: Grove Press, 1960.

Ashbery, John. *The Double Dream of Spring*. New York: Ecco Press, 1976.

_____. *Self-Portrait in a Convex Mirror*. New York: Viking Press, 1975.

Breton, André. *Nadja*. Translated by Richard Howard. New York: Grove Press, 1960.

_____. *Surrealism and Painting*. Translated by Simon W. Taylor. New York: Harper & Row Publishers, 1973.

Dijkstra, Bram. *Hieroglyphics of a New Speech: Cubism, Stieglitz, and the Early Poetry of William Carlos Williams*. Princeton, New Jersey: Princeton University Press, 1969.

Heidegger, Martin. *Poetry, Language, Thought*. Translated by Albert Hofstadter. New York: Harper & Row Publishers, 1971.

Jakobson, Roman. *Selected Writings*, vol. 2, *Word and Language*. The Hague: Mouton, 1971.

Klonsky, Milton, ed. *Speaking Pictures: A Gallery of Pictorial Poetry from the Sixteenth Century to the Present*. New York: Crown Publishers, Harmony Books, 1975.

Lee, Rensselaer W. *Names on Trees: Ariosto into Art*. Princeton, New Jersey: Princeton University Press, 1976.

_____. *Ut Pictura Poesis: The Humanistic Theory of Painting*. New York: W.W. Norton & Co., 1967.

O'Hara, Frank. *The Collected Poems of Frank O'Hara*. New York: Alfred A. Knopf, 1972.

Padgett, Ron. *Great Balls of Fire*. Chicago: Holt, Rinehart & Winston, 1969.

Padgett, Ron and Shapiro, David. *An Anthology of New York Poets*. New York: Random House, 1970.

Perloff, Marjorie. *Frank O'Hara: Poet Among Painters*. New York: George Braziller, 1977.

Schapiro, Meyer. *Modern Art: Nineteenth and Twentieth Century*. New York: George Braziller, 1978.

_____. *Words and Pictures: On the Literal and the Symbolic in the Illustrations of a Text*. Hawthorne, New York: Mouton Publications, 1973.

Stein, Gertrude. *Last Operas and Plays*. New York: Random House, Vintage Books, 1975.

Stevens, Wallace. *The Collected Poems of Wallace Stevens*. New York: Alfred A. Knopf, 1954.

Williams, William Carlos. *Selected Poems*. New York: New Directions Publishing Corporation, 1963.

Wolheim, Richard. *Art and Its Objects: An Introduction to Aesthetics*. New York: Harper and Row Publishers, 1971.

Poet, scholar, critic, and musician, David Shapiro is himself an exemplar of the interdisciplinary and multifaceted artist he has described here. Born in 1947, he made an early debut as a professional violinist and, while still an undergraduate, published his first book of poems, January *(1965). His third book of poetry,* A Man Holding an Acoustic Panel, *was nominated in 1971 for the National Book Award, and he received the Morton Dauwen Zabel Award in Poetry from the American Academy and Institute of Arts and Letters in 1977.*

Educated at Cambridge and Columbia universities, he has taught nineteenth and twentieth century literature at Columbia since 1973. With Ron Padgett, he edited An Anthology of New York Poets *(1970), and his critical study,* John Ashbery: An Introduction to the Poetry, *has just been published by Columbia University Press. Shapiro's interest in the visual arts led to articles in* Art News *as early as 1969 and recently culminated in his being named to succeed Harold Rosenberg as art critic of* The New Yorker.

Bernadette Mayer

Rosemary Mayer

I first met Rosemary Mayer in May of 1945. She was then busy accumulating a wealth of analogies and ideas which she could only express in language and gesture at that time. Later her formulations led her to be interested in astronomy, history, story-telling and the rendering of fabric and other materials into various fantastic costumes and visual situations. Though her studious attachment to classical texts and histories portended for some years a life as a scholar, she had from her youth such a sensible love of the real stuff of things, gardening and flowers, color and carpentry, that it could not permit itself to go unexpressed. Her early paintings were experiments with color and form on a flat surface but secretly, hidden among her papers, there were always sketches and drawings of an incredible nature, hiding flowers and Indians, whole tribes of them, studies of the Peloponnesian Wars all intimated in the flash of a fine black pen. She would never sketch a figure but if you told her your imaginings, there they were in an instant on the page.

Though she has since created formidable sculptures in wood and aluminum, cord and wire, fabric and fiberglas, it is this ability to connote as it were, with images on flat surfaces, drawings and watercolors and paintings, that has always bespoken for me her particular knowledge. So that when I saw *Insistently Reappearing*, I felt compelled to write this description of the work:

It's in a big frame, this pillar of flame, what clothing is this engaging forms but not enfolded by their arms, the insistently reappearing invisible ones beneath the hegemony of a confederacy of skirts, on the surface to be seen, in billows like balloons or as they are folded to be dyed in the tub, dyed perhaps indigo with an ancient commitment as to the meter of heroic verse,

Some beauty rare, Calisto, Clymene,
Daphne, or Semele, Antiopa,
Or Amymone, Syrinx, many more
Too long, then lay'st thy scapes on names adored,
Apollo, Neptune, Jupiter, or Pan,
Satyr, or faun, or sylvan? but these haunts
Delight not all; among the sons of men,
How many have with a smile made small account
Of beauty and her lures, easily scorn'd
All her assaults, on worthier things intent?

As Satan speaks to Belial in Milton's rhapsody, so the folds of the fabric whether painted or true, cover a system of naming, of naming's intent, to lay claim to, of naming's device which is poetry, static intimations of history in the lush prose of color, hiding, always hiding. Who are these absent forms? Forms leaning back or over in a bout with religion, who specified that they could exist in such a space, space without flatness, drawn up in a whimsy of the articulation of a sculptural regime in a flat area like the field of a farm made to hang on the wall. That's description, description is insult, the secret need for beauty as in Satan's assault on Belial, belies this fashion of laying claim to a work and ferreting out its secrets, some vision of innocence rendering passion distinct from lust and even fashion. Inherent in this world is an abdication of the figure and a lust for it, secret envy of the greed of claiming the human form to be one's own in writing, perhaps in the titling of the work. It's an airy fight but not superfluous to see all these trappings, are they still or moving, of ecstatic remorse at what is seen, put down with energy in an attempt to be done with the old by suggesting its cloud-like currency in intimate detail.

June Flowers, 1976
Watercolor, 31 x 47 in.
Collection of Robert C. Hobbs, New York

Rosemary Mayer

Bernadette Mayer

Rudy Burckhardt

Weight of snow on the roof
I look, I lower my eyes
People looking down, there's
A habit of sudden movement, quick
Change in the still frame as if
Each image were the very next
Ashes, all fall down
There's the sight of the building
The painter dips his brush into the color
As light falls down

She hurries to catch the light
I ride by insensitive
I write in a codebook the covers of which
Will lengthen our search, words false as a tree
Among the pictures of cities, another story running

Who are the actors, there's
The old woman walking
With a bow atop her hat
Before the blissful realization
Of adamant eyebrows, there's
Sleekness, it's simple,
Reflection, absent whispers,
Edwin, the shepherd,
He walks miraculously
Down the center line
It's not there, his white hair
Catching the light, there's
A package in the crook of his right arm
He's in the lead, he's winning,
This procession is a race
He is in the bishop's chair, the host of all
The window's cold the snow is drifting
Up to the top of the red brick wall
There's color

The white line for walking
Is a plane in your painting, in culture
I planned the shadows cast on it
To be those famous green alligators
Beneath the polished manhole covers
Spaced in the New York streets
Cluttered with puddles, there's
No debris, I see
The shadow of a woman's two thin feet
High heel shoes centered in the ring
A car goes by, the woman is walking
A car goes by, my eye
Is caught by the glittering can
Smashed in the gutter, in culture each man
Has tastes and manners of his own

I look around indoors
There may be a family sleeping
Or looking out at the storm, keeping
A vigil on the eve of a festival

In culture it's walking the streets that I see
And looking at each man and woman
My eye is smashed in the ring of sleeping
Water blurs the edges of the totem you've made
Of this building, sudden change,
Light falls down

The feet of the building are lost in the sky
Are we old? So many windows falling in the willing gray rain
Do I hurry by? Wind mottles the water, the man is running
The middle space is lost, the avenue is cast
In clear gray, have I mistaken you for another?

Now the snow is deep as the city's sudden gray
Now the story, those men and women, look up and lead away
There the image falls in reflection's impervious night
Here the wind staggers drifts in the snow's uncertain light

From *Flatiron Building Reflections*, 1979
Black and white photographs, each 14 x 10 in.
Collection of the artist

Rudy Burckhardt

Finishing Touches

On the Painting of George Schneeman . . .

It has been said that there are people who, upon first seeing George Schneeman's paintings, exclaim, "Aha! Alex Katz!" Perhaps these people are suffering from having read too many art magazines, or from overindulgence in gallery-going. Gallery-going is a wonderfully pleasant and sometimes exhilarating pastime; at best it gives you the impression of being in the foreground of modern art, an exciting if not always appropriate place to be; at its worst it turns one into a gibbering idiot, tattered gallery guides clutched in hands stained with the New York afternoon, an afternoon that took them past, say, a print by Alex Katz, on their way to a show by this George Schneeman. Better that they look and simply exclaim, "Aha! George Schneeman!"

Or that they be patient enough to have it dawn on them that the antecedents of this work, if they are to be sought, are to be found elsewhere in space and time, in 14th and 15th century Tuscany. They are to be found in the frescoes and altar paintings of the imperturbable Duccio and Giotto, in the pale angels of the angelic Angelico, in the workmanlike productivity of the Lorenzetti brothers, in the simple and mysterious little pictures of Sassetta, and in the draftsmanship of Masaccio. All of which does not make George Schneeman's pictures any better or worse—it just introduces some common sense into the conversation about them.

Normally I don't say much about George's pictures. I watch him paint. I sit for him, and I watch his face, so grim and funny as it comes to a point at the tip of his nose, which is like the barrel of a rifle his eyes squint down as he glances from subject to painting surface, grumbling vaguely about how badly it's all going. When it's time to stretch I walk over and take a look. The picture is looking okay. I try to see what is in it to make him so disgruntled. Then I resume the pose. This goes on for a period of hours, perhaps over several days, depending on the size and medium of the picture. Then it is basically completed, lacking only a few finishing

touches. It is beautiful—mild, balanced, well-drawn, firm, straightforward, and sometimes serene. It is also light, modern, attractive, clear and likeable. It is not outrageous, declamatory, shocking, sneering, trendy, bizarre or shrill. It is good. Sometimes it is affectionate, when the subject is George's wife or one of his sons. Occasionally it is playful, in composition, but the playfulness is something that happened to occur along the way.

"That's a real nice painting of Elio there," I say. "He looks as though someone just hit him in the forehead with a mallet."

George and I laugh.

"That really is a good painting," he agrees.

We laugh.

"But this one over here . . . ough! Katie's head is totally tiny *and* bent!" I groan.

"Yes, that one is a little off," George laughs, slamming the palm of his hand down on the table.

The dishes are being cleared away. Now only the coffee cups and the espresso pot are left, with several empty bottles of Bardolino, and a generous sprinkling of crumbs, with a few ashtrays, and cellophane wrappers torn from Garcia y Vega cigarillos. Let us admit it, we love Garcia y Vega cigarillos! We especially like the scene depicted on the box, the Spanish girl next to the tree with her initials and those of her lover inside a heart shape carved into the trunk.

Allen (Ginsberg), 1978
Fresco on cinderblock, 8 1/2 x 7 1/2 in.
Holly Solomon Gallery, New York

George Schneeman

. . . and Pat Padgett

At the other end of the table, Katie and Patty are talking and laughing. Sometimes Katie turns her head sideways and goes as to lay it on the table as she laughs, and the tears roll out, she laughs so hard, her voice rising to operatic volume as she repeats the punch line, which in fact *is* very funny. Even Patty is rolling on the floor (in her mind).

We are all happy because it is George's birthday, and he did not want any special attention, and we gave it to him anyway, and he liked that. He liked the little painting which Patty has given him for his birthday, you could tell he genuinely liked the painting and was happy to have it. It is in a manner different from his, and we do not really understand why he likes it.

It shows a little old woman sitting at a table, facing us, in a breakfast room with a cupboard and a door and some wallpaper. The colors are pale: gray, pink, blue, green and white. It has the clarity of a comic strip, without the hardness; it brings with it the lightness of the comic strip, made even more soft and lovely by its soft colors, in perfect taste. The figure and objects float slightly above the ground, not sure they belong together, but shrugging their shoulders good-naturedly. Of course a table cannot shrug its shoulders: it has none. I just wanted to give you an idea of the feeling in the picture.

It reminds you of Grandma Moses, a painter you like more and more. That is truly incredible. But, on the other hand, how could anyone dislike an artist named "Grandma"? The image of a little old woman, something like the one in the picture, is highly comforting, especially when she is painting beautiful and naive pictures. It's as though a clear underground stream had burst from the side of a hill, just when you realized you were terribly thirsty.

That kind of fortuitous surprise springs forth from Pat Padgett's pictures from time to time. Each picture is an adventure: you look at it apprehensively, as though you fear it might fly to pieces and be a bad painting. Then you breathe a sigh of relief, you see it might not be so bad after all. The more you look at it the more you like it, to the point at which you turn around and say to the person in the room, "Hey this is really nice!" And for you another turn has been taken in your experience of modern art: you have seen something that you had never seen before, and now everything is different. It's better.

Untitled, 1977
Watercolor, 10 x 8 in.
Collection of the artist

Patricia Padgett

Kenneth Koch

Larry Rivers

Before I met Larry Rivers I saw his paintings. Jane Freilicher had some. Clement Greenberg said he was "better than Bonnard." For me those tall wide paintings with girls in orange rooms full of tables and thick white framed windows and lamps with cherry-colored or violet shades were better than Bonnard for one thing because I was discovering them. I was there right next to them and no one else was looking except (sometimes) Jane. I had a curious feeling. This was the first time I had a feeling of absolute sureness about the paintings of anyone I knew or was about to know. Anyone near my age. I was nervous and excited. I thought Larry is going to be great. And famous. I said that to Jane. I said Of all of everybody, by this time I had met Larry, Larry is going to be (the first to be, certain to be) great, and famous. Larry was great and famous with me the minute I saw his work. Jane's paintings I loved after I got to know Jane, whereas I met Larry through his. Larry at that time was working on his skill at drawing. He imitated Rembrandt and Rubens and Ingres. Everything he did was gorgeous. He was dark, nervous, troubled, anxious, malcontent. He was ambitious. He really wanted to be great and his incessant drawing was part of it. I started collaborating with Larry on a lot of things. He put some color on a canvas or a piece of paper and I wrote down a word or phrase. He painted something, sometimes covering up what I'd written. I wrote some more, sometimes going over what he'd painted. In this way we did about three dozen works—*Maps, Shoes,* the *Daily* and *Sunday Screw, Fish,* and a bigger canvas *New York in the 1950s,* with Frank O'Hara's face on it and Wah-Kee's restaurant, the Cedar Bar, etc. Those were the collaborations we did that were most exciting, when we were both working on the same piece of paper or canvas at the same time. Larry would put on some color then walk away and whistle. I'd say Stop whistling. I can't think. I wanted to be

inspired by his painting and not by his nervousness and whistling. From Larry and Jane I learned to draw, to paint, to look at paintings. I did pencil and charcoal copies of Delacroix and Ingres. I smudged things. From Larry I picked up the beauty of messiness. After a year or two I gave up painting and went back full time to poetry. This was still in the heroic (early) phase of our friendship. With Jane and with John Ashbery and Frank O'Hara we went everywhere together. Anyone who invited one of us got us all. Larry often played the piano at parties and sang a song he had written called "My Nose." This was usually quite late in the party. Larry and I had various mildly self-congratulatory conversations about why we became artists. The answer of Larry's I remember is "I think I wanted to be able to say to my mother when she knocked on my door, 'Go away, I'm doing something important.'" Larry was and is. It is hard, though, to stay out of his room. I have almost never had an uneventful conversation with Larry—that is, if the conversation lasted for more than a few minutes. Frank, John, and I wrote a play for Jimmy Schuyler's birthday years ago with our friends as characters. Frank wrote most of the lines attributed to Larry Rivers, who began saying, about the middle of the play, which was about a party, "Well, I've got to be going." He kept saying this till the end. What I was saying is that when Larry isn't leaving, he's as interesting as anyone on earth. His work has inspired me—that's the right word—for thirty years. I love its sensuousness, its talkiness, and its scale. Every detail in it is always suggesting something, the paintings sometimes even seem to be composed that way. Doing them is Larry, taking everything seriously because it's interesting to see it that way, in his talk and in his work. It seems one of the undeniably good things about my life that my association with him has been going on for so long.

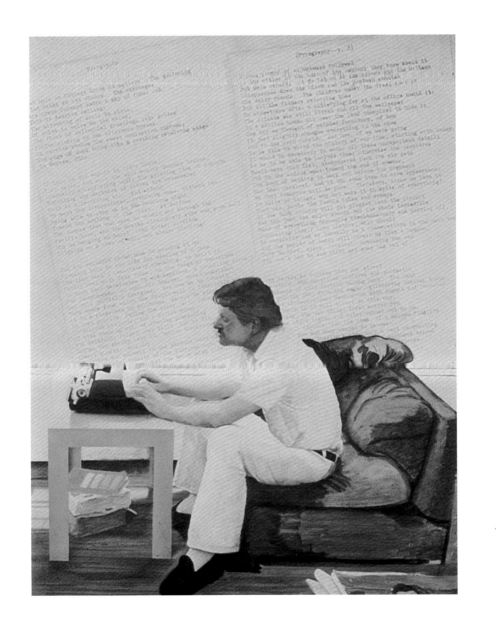

Poem and Portrait of John Ashbery, 1977
Acrylic and pencil on canvas, 76 x 58 in.
Marlborough Gallery, New York

Larry Rivers

Kenneth Koch

Jim Dine

I saw Jim Dine's work long before I met him. Dazzling bathrobes, neckties, hammers, hearts. The paintings were very convincing. So was Jim when we finally met. We decided it would be nice to do a work together, a book of which each page would be made of a different material— there would be a tin page, an aluminum page, a plexiglass page, a wooden page, and so on. I was to write some words inspired by Jim's inspiring heavy pages. We shopped on Canal Street for materials but never made the work. I don't remember why. We did do a poem/painting together and a work for *Art News* called Quiz on Art, in which I asked sixty-six questions and Jim answered them. Later I visited Jim in London where it seemed to me he had a fabulous life. His beautiful paintings and his forceful sense of who he was and what he wanted to do formed a wedge that cut into London in such a way that everything and everyone fell into his life and into his Chelsea house. At this time Jim was writing names all over large canvases and also filling up other canvases with different-colored hearts. The hearts got to me. They were characteristic of the way he isolated an object one dreams about and gave it a big white canvas world, or heaven, of its own. So at last you could have all of it you wanted, and just as you liked. He did this later with other things, most recently glasses. I saw these on a huge canvas on the wall of an elegant Fifth Avenue hotel of which Jim had become the only ever existing painter-in-residence. At least, he had two (or three) rooms in it, one (or two?) converted into his studio. I have always found Jim Dine slightly intimidating because he always knows what he wants to do. I am not sure he knows this but I don't suppose he'll mind. Here is a part of our Quiz on Art—

Q. 17. Imagining anything is possible, what commission for a work of painting, sculpture or architecture would you like most to be given right now? A. I would like all the billboard space between any two towns.

Q. 14. If you could have your most recent painting placed anywhere you liked, where would you hang it? A. In my house.

Q. 47. Do you feel that you could be a more complete artist if you could come back from the dead? A. I'm already back.

From *Mabel*, 1977
Etching, 19 1/2 x 15 in.
Pace Editions, New York

Kenneth Koch

Red Grooms

My secret feelings for goofy cartoon faces and bodies, for bumps and lumps, for tiny meticulous slightly messed-up versions of things like cities and ships became slightly altered as a source of inspiration for me when I saw Red Grooms's work and realized what he was doing and had already done with all these things, really loving them and crazy about them and with a view of the beautiful and the goofy that made it necessary to think and feel about them now in a new way. He'd appropriated a part of my childhood and all sorts of notions and intentions and odd conceptions and was working away at making of them something amazing. A very very tiny room, three-inch-high walls, with a washbasin and hung on it a washrag, one eighth of an inch—with blue and yellow and red stripes. In another minuscule room there was a newspaper and a tiny water glass. There may even have been matches. The work gave certain sensations I never found elsewhere but that I suspected sometimes and had thought to be one of my secrets.

When I'm unnerved and delighted by someone's work I often like to collaborate on a work with him, partly to participate in his energy and to see what will happen. Red did sets for a play of mine, *Guinevere,* that I thought no one could ever produce (or do sets for). Much later he did some sets for my play *The Red Robins.* One scene he did was the city of Shanghai. His set was so beautiful I wrote another scene into the play so the set could reappear. The sets for both plays were full of mystery and a slightly dangerous-seeming happiness. I love this vision of happiness in Red's work and the way he can fill up such a vision with things. We also worked together on a series of cartoons. I gave him some short poems which he made into the cartoon speeches of various heroic, exotic, and comic-strip figures. It was a surprising pleasure to find my poetic lines issuing in conversation balloons from the mouths of Attic philosophers seated in bathtubs or veiled women on camels or children mopping a floor or running into school or elephants at ease in the zoo. It seemed to give them, as Red Grooms's set did for the Shanghai scene, some sort of final authenticity, and it gave me the pleasure of having my writing once again inextricably mixed up with Red's art.

Stage set for Kenneth Koch's play *The Red Robins*, 1978
Wood, 12 x 10 x 4 ft.
Marlborough Gallery, New York

Red Grooms

Bill Berkson

On Four Hearts

1.

In the etching, men and women
with no clothes on, touching, are
either swimming or flying
into veined air out of moiré water.

2.

Set your sights on the flower arrangement.
The beanball knows behind it,
can't decide, looks to the side:
white cup, magenta smile.

3.

The Great Diagonal, no less!
Frayed edges and crosshatchings,
like bedding notched.
Hot tots! We love getting carried away!

4

Feather be my field.
What the curtain rod joins, let the heart affix.
Yellow of her favorite color.
Yellow of my favorite dress.

To Lynn

The wind is blowing hard, and you walk
through its force to loose this morning's lost bunny
in a field of scrub. It's like everything is adangle
from this earthy grip. You watch patiently. The rabbit runs off.
I watch you. You are bigger than the bushes, and like them, not
to be bowled over, unlike me, by a whim. Head up,
you are fully aware of the clouds, and when there aren't any
you take in a lot of light. You give off a lot of heat in
the form of color. Today you are wearing white.

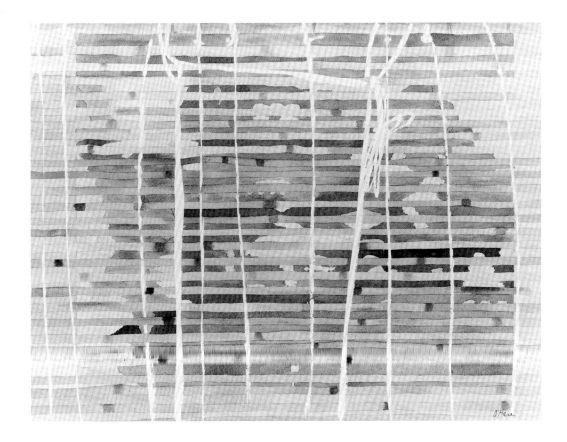

Blind, 1979
Watercolor, 18 3/4 x 22 1/4 in.
Collection of the artist

Lynn O'Hare

Bill Berkson

Source

to Philip Guston

With thought first the dotted sun
Tantalized youth & darkens words
All the vain, some pure lump at rest
Sucking visible red ripe bone

Ways refuse to pull apart
Destinate melt-line tacks its comprehensive mound
My smokes rise high
Silent face that no less clarifies

Utterable reckon at perception's edge
Words consubstantial home to nothings waiting
Dumbfound here with air & hating
Strange to grow a bush of parts

I who am continues behaves
Like who isn't
Glistering shadow
The fuzzed sky light strikes

Oblique effortless to realize vacant
Building plausible dimension whence
Whole dawns premises exemplary embark

Midnight Pass Road, 1975
Oil on canvas, 67 1/2 x 97 in.
Private collection

Philip Guston

 Johns
 Anyone
 Structures
 sculPtor
 hE
 chanteRelles

 Jewel
 cOnceives
 He
 paiNt
 concluSion

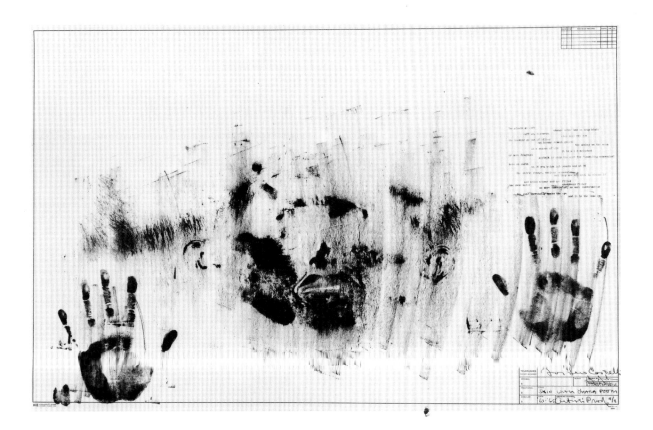

Study for *Skin with O'Hara Poem*, 1963-65
Lithograph, edition of 30, 22 x 34 in.
Collection of the artist

Jasper Johns

John Cage

pRinted
Of
Both
lifE
neitheR
acT

youR
A
pictUre
Seen
Counter
witH
stEp
paiNtings
Both
lifE
neitheR
Gap

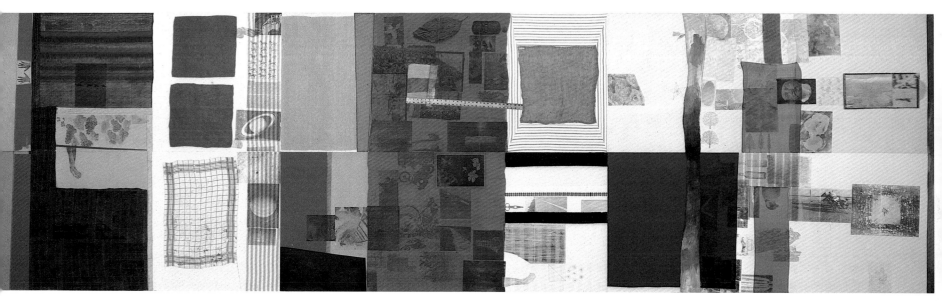

Half a Grandstand (Spread), 1978
Mixed media, 84 X 252 x 2 in.
Collection of the artist

Robert Rauschenberg

Barbara Guest

Latitudes

(The Art of Fay Lansner)

We were looking for flowers,
For their essences often curtains
Sketching a window.

We were looking for the red green blue
Of a substitute country.

The mind travels over it penciling in
The routes, especially ponds
And shapes like laughter.

In the distance disguised as canvas
We leave our usual motors
To rely on this arm to guide us.

Yet ignoring landscape it says:
"Odd rhythms become domestic."

Crayons deposit skin on faces
Cheekbones follow them out of the alert
Rooms into shadows,
And flowers are resting in the shadows
Near the conversations.

She drops a hint a child
Gathers it up and the curtain
Falls because it is nighttime.
The decline of stretching,
The hour of cushions
And bringing together
Of poles once named oppositions.

Then later we discovered
Metamorphosis was their difficult answer.

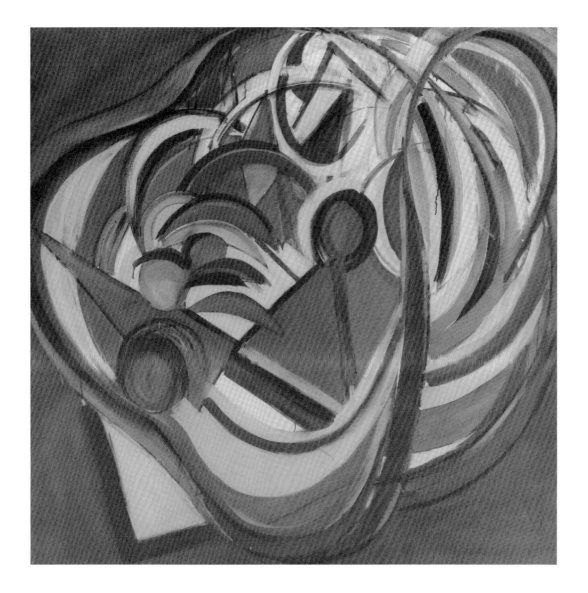

Women in Space, panel III, 1978-79
Oil on canvas, 60 x 60 in.
Collection of the artist

Blue Endings

Strips of green
Related landscapes

That cinnamon was brought from Mexico to New York

(Chirico?)

Loneliness of spirits
A fictive loneliness
Escape cut off

Greyed tones
Violets
Geometric shapes turning into trees, buildings,
Transported landscapes

Tenderness, carefulness of approach

Longing for rigidity to lapse
For nature to release her touch

Earth colors painted on the canvas eye
Acrylics tamed into oils

Magic (details)

The word is *inscape* bringing us closer to the skin

That sudden curve of blue brings tidings

Organized space in Renaissance color

Tightening-loosening time controls

Time relinquishes

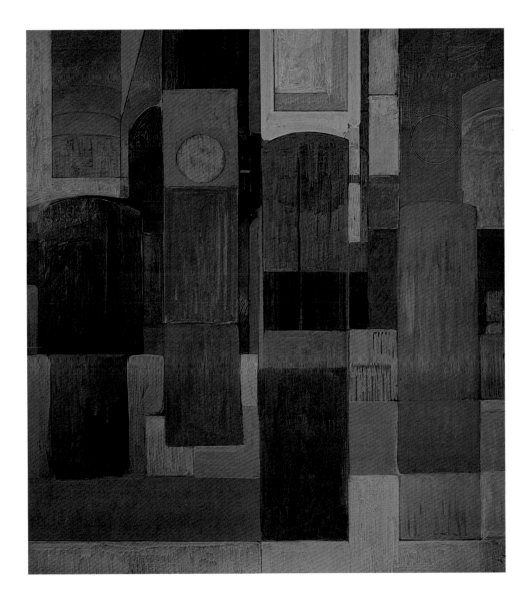

Untitled, 1979
Acrylic on canvas, 48 x 42 in.
Collection of the artist

Robert Fabian

James Schuyler

Anne Dunn Drawing

A snarl of colored inks
ignites the tree.
Burn in yellow
cool yellow.
The air is stippled:
the air is everywhere:
in gusts and layerings.
Flowers lie along the ground.
The fisherman's shack is white and red:
a white shack with red trim.
Music rends the sky,
which is no color at all.
Tomorrow
why not today?
Anne does the cloud laundry.
She irons them flat
then puffs them up
in gentle rounds.
In all she draws there
is the metaphor
of the permanence of change,
a poem to the eyes.

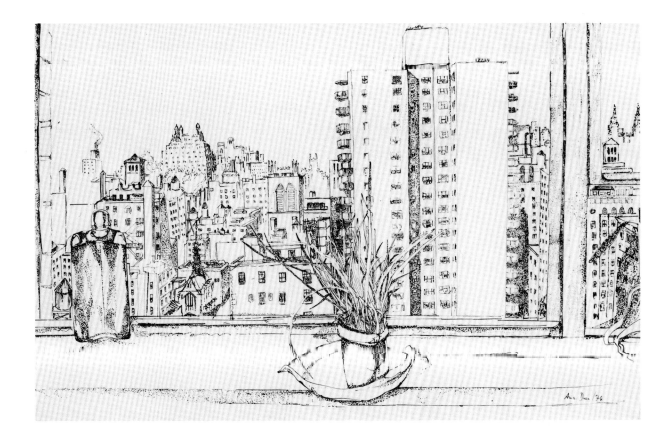

Manhattan, 1974
Ink on paper, 18 1/2 x 29 in.
Fischbach Gallery, New York

Anne Dunn

James Schuyler

Looking Forward to See Jane Real Soon

May drew in its breath and smelled June's roses
when Jane put roses on the sill. The sky,
in blue for elms, planted its lightest kiss,
the kind called a butterfly, on bricks fresh
from their kiln as the roses from their bush.
Summer went by in green, then two new leaves
stood on the avocado stem. The sky
darkened the color of Jane's eyes and snow
wrote her name in white. Such wet snow, that stuck
to the underside of curled iron and stone.
Jane, among fresh lilacs in her room, watched
December, in brown with furs, turn on lights
until the city trembled like a tree
in which wind moves. And it was all for her.

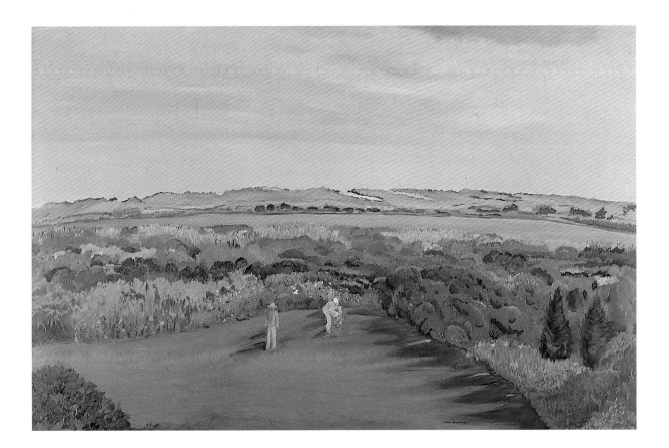

The Gardeners, 1977-78
Oil on canvas, 51 x 77 in.
Fischbach Gallery, New York

Jane Freilicher

I *(for Sylvia Sleigh)*

Two quotes:

"Women are equal and must be
treated as such. To do otherwise
is simply unfair."

"I always forgive, but I never
forget."

To describe how someone looks
is to describe oneself
inadvertently
or not,
so please come dressed as you are
and she will examine our disguise
in a celebratory way . . .

[Lunch break!
Cheeses and water biscuits
(my favorites)
some wine
in a Chelsea (New York City) garden.
But why won't the phone stop?
And where is Zelda[1]?
(Lawrence[2] is at Stony Brook.)]

• • •

Ira has the hives and is being attacked
by every known insect
in the vicinity of Southold[3].
We pose together for
"The Good Angel and the Bad Angel."
But which is which?
Hair color should not deceive.

We were there together
unlike when I posed
for Sylvia's Turkish Bath painting
and Scott Burton and I never posed together,
accounting for the seam of light
between our naked forearms?
[Dark frills and patterns
behind male nudes,
all of us naked critics
except for Paul,
seen twice,
a bracket to our modest revelations.]

And then I remember her Pan too,
thinking it should have been me
since once I dressed
or undressed
as Pan for Halloween.
[Paul and Susan superimposed
became Lilith.]

Women! The Soho Twenty and A.I.R.
giving such a breath of fresh air to art,
contradictions of Courbet's great studio painting
or the Max Ernst catalog of surrealists.
Women! I am allergic to them
(and to men too)
but I affirm their dignity.

footnotes:
1. A beloved cat named after Zelda Fitzgerald.
2. Lawrence Alloway.
3. On the north fork of Long Island where two summers Ira Joel
 and I were guests of Sylvia and Lawrence.

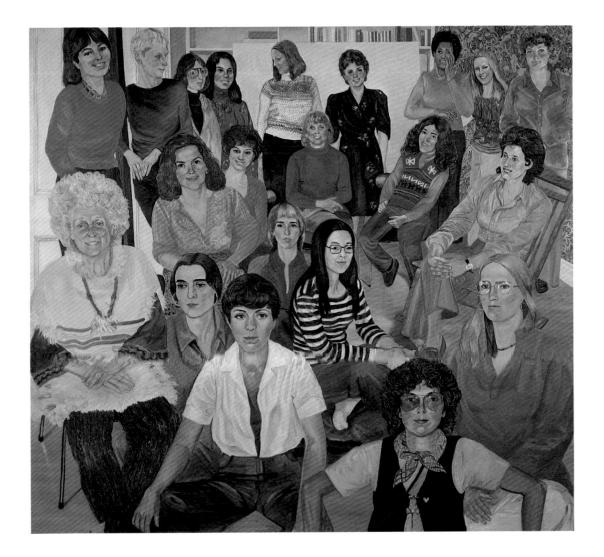

A.I.R. Group Portrait, 1978
Oil on canvas, 76 x 83 in.
Collection of the artist

Sylvia Sleigh

John Perreault

II *(for Ira Joel Huber)*

Two quotes:

(said after a successful exhibition in
Germany)
"Now they want to put me in the museums;
not so long ago they would have put me
in the ovens."

"How do I know when it's art? When it
gives me a hard-on."

The heart of the matter
does not describe
such bitter landscapes
as this world departs
within aquariums
and I/you disintegrate
only to come back together,
the landscape worried.

The heart of the matter
 park
 scar
 car
 shelf

 does not describe
 inscribe
 imbibe
 revive
 ascribe

such bitter landscapes
 better
 violent
 butter
 funny

as this world departs
 scar
 death
 wound
 dance

within aquariums
 terrariums
 deliriums
 hurricanes
 turtles

and I/you disintegrate
only to come back together,
 the landscape worried.
 harried.
 Harry-ed.
 glowing.
 asunder.

My Landscape Grows Older When I'm Not with You, 1974
Mixed media, 8 1/2 x 120 x 12 in.
Collection of the artist and Pam Adler Gallery, New York

Ira Joel Haber

Mr. Minotaur Builds a Labyrinth

for Rafi Ferrer

And then
he builds another. Posing

for this quasi-official portrait

drives our latest labyrinth
around a nearby bend in the beach.

The tide rushes in,
if you see what I mean.
If you don't, it rushes up

to you, to your
own tide, a foam of unseeing,
groping, and the unofficial tide gropes back,

at that image of yours,
the young republic's population
of wicker in the shadow and the flesh

to carry its imprint into the sun.

Posed at the wheel
of our political machine, quasi-official lust
drives its denial deep

inside a labyrinth of accountability, a culture
of explanation,
a perversion of walls.

Why must they be floors?

Posed by quasi-official media,
this question drives our youngest labyrinth
up the walls, her own.

But why must they be floors?

Mr. Minotaur
encourages these speculations, all the better
to corner the market matching demand
for gropable walls

to our supply of floors, our mappable regions,
infinities

of wicker in sunlight and the breath
to install that image in darkness,

to corner it on a terrace of endless day.

You were right
to accept that quasi-official position,
that sleepwalker's portion, right

to grope your way out of those complications.
What else are complications for?

As for the twilight of explanation,
that offer of endless insomnia—why not just
relax, install yourself beyond the threshold,
if you see what I mean.

If not,
just keep an eye on meaning's lagoon.

Up to her knees
in a tide of unseeing,
this latest labyrinth

abandons the political wheel, connections, her image,
at the threshold of unofficial lust, the terraced

ocean bed, tilted
floors,

a sleepwalker's explanation, a politic posing
as an endless supply
of deep need

for air, for example,
on gropable floors, for another,

where the labyrinth wakes up, consisting of ocean
for another—for me,

Mr. Minotaur,
inside the pressure of light and air where I
hear myself asking, Why must they be walls?

A-af, 1979
Crayon on navigational chart, 44 1/2 x 60 1/2 in.
Nancy Hoffman Gallery, New York

Rafael Ferrer

Carter Ratcliff

To Light

for Willem de Kooning

Shine, Light,
even in the dark,
on our gazes,

dark to us always. Lost, you see,
to that darkness of yours,

for to see at all
is to see all manner of loss lurk in the air,
half in disguise,

as of the sun half-set, and
absolutely mute.

No note
of truth

nor even a note faked solemnly
at home in days prismatic.

And greasy
on your tides, refurbished Light,
the model of adulthood sometimes

crystallizing,
sometimes filling up your lap with sallow leaves,
or emptying your ear

of troublous city noise. Light, you've had such
opportunity, knocked on all those mote-filled doors.

So many new apartments,
so little time for politics.
Your dim-discovered sexiness

attacks like strobes
our theories which are noted: cracks across your window,
Light.

And then we think
what we sometimes feel
is pushing your transparency aside
on hinges that we always feel

are yours
and turn us back toward you, evaporating Light,
on hinges that evaporate as fast.

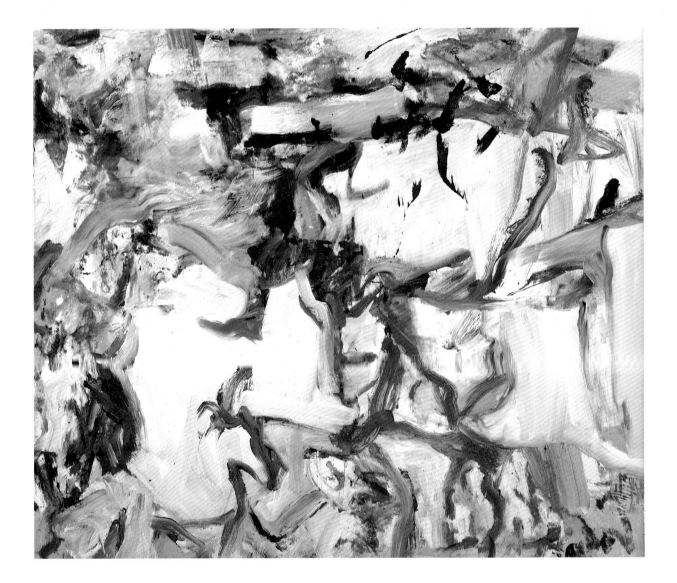

Untitled XXII, 1977
Oil on canvas, 70 x 80 in.
Xavier Fourcade, Inc., New York

Willem de Kooning

Peter Schjeldahl

Alex Katz

Alex Katz has been a friend and hero to New York
poets for a long time. For many, myself included, he
is an image of *the* "New York artist": tough,
talkative, graceful, with an esthetic bias in
everything, maker of a life and an art as sveltely
sturdy as a skyscraper. His startling intelligence is
revealed in judgments exquisitely just and
unfair; his aphorisms get passed around among his
friends like funny talismans. Both life and art seem
to him a test, even a contest, and there's no denying
he's a winner. To our delight, the severe and
sociable beauties of his art invite us all to share his
winner's circle with him. He is a living standard of
nerve, seriousness and style—all the New York
virtues. He is also, not incidentally, some kind of
great painter.

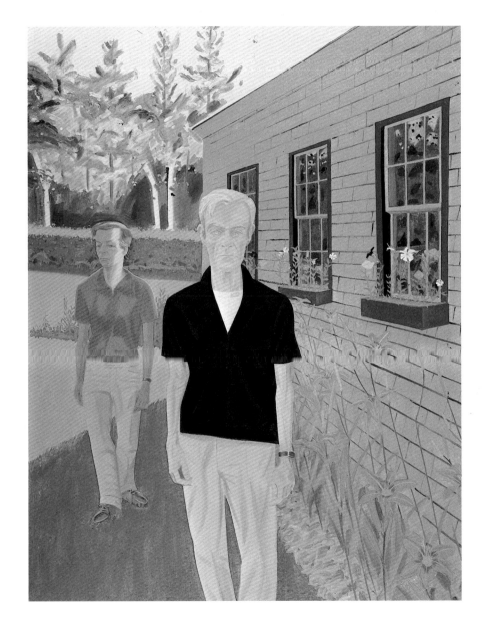

August Late Afternoon, 1973
Oil on canvas, 96 x 72 in.
Marlborough Gallery, New York
Not included in this exhibition

Alex Katz

Peter Schjeldahl

John Seery

John Seery has been one of my favorite painters
ever since I first saw his work, late one night in
1969 in a crumbling waterfront attic on Fulton
Street. I was awed and excited. It was as if I'd
always expected to find someone my age who
painted just this way, and here he was. There have
been changes in Seery's work since then, but what
has never changed, for me, is its incredible
amplitude, of technique, style, color, scale, spirit, of
everything. Part of what I admire in this art is an
unironic commitment to sheer beauty, splendor,
sensual pleasure, maintained in the teeth of a
puritanical conscience impossible to placate.
Sometimes the conscience seizes the brush and
vandalizes a canvas; at other times it's in a stupor
and facility results. But the drama of the tension is
continual, and terrible and terrific, and when
everything is in balance and working right it just
kills me. Some people share my feeling about Seery,
and some don't. I don't care.

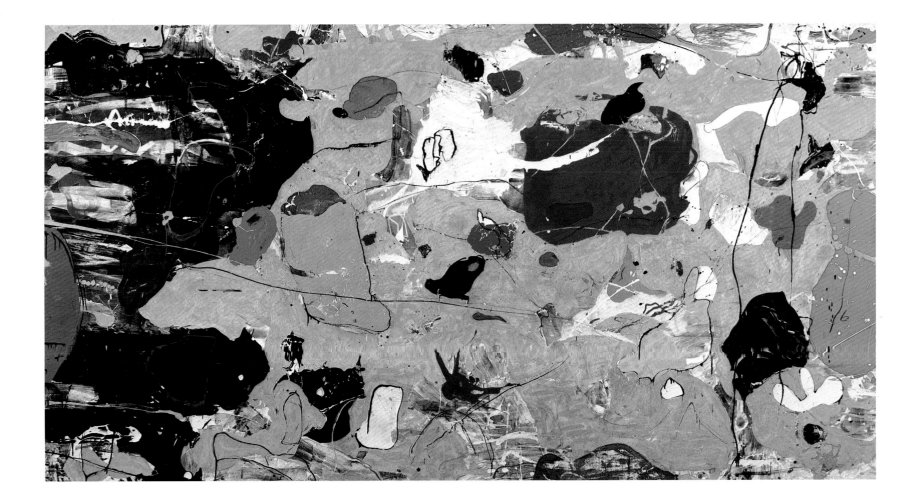

Gamut, 1976
Acrylic on canvas, 116 x 210 in.
Max Hutchinson Gallery, Houston

John Seery

Anne Waldman

Gut Convinced

"We are the driving ones" — Rilke

She is sometimes in Maine she is often above the clouds
she is always seeing with the weight of light upon her

What she is seeing what she is telling us like no other
telling us you will see you will see not a method

Not a surface not so but just so painterly when I think
of art when I sit to think of art when I sit to think

To print of art when I print of art
Yvonne Jacquette at the ballet Yvonne Jacquette not pompous

Not intending but not so just so daughter of a Catholic
I will always think of Gertrude when I sit to think of art

When I sit to think to print of art when I print of art
Yvonne Jacquette practicing strain of grace

Like veins like maps life since the airplane since
the first woman looked over looks down looked up

Then she looks up then she is looking down
painting to picture to painting a traffic light pause

Irving Place mid-afternoon buildings alive like moss
I thought I'd entered daylight for the first time

All art's a picture she's classical painter
moody patches of color moody patches of color

Little movie marquee painting 14th Street paint sky angle
which is the most difficult to hold ardent for her art

Seeing the solids in the light gut convinced
repetition and relief to do something difficult

To do something tremendous aviator browns and blues
she is scaling tall buildings now the world taken apart

And put together again she of character spelling poetry
and series of strokes by eyes to hand for eye

No motor trouble "le dolce rime d'amor" tone of stretch
pull force strength demand to think of art

To sit to think to print of art Yvonne Jacquette at the wheel

Irving Place Intersection, 1975-76
Oil on canvas, 70 x 80 in.
Brooke Alexander, Inc., New York

Yvonne Jacquette

Love of His Art

to Joe Brainard

I have not mastered cinematic intelligence
screen gone, but
each little mannerism aspen shuddering:
 the storm is here, the storm is here

Keep even smoothness spread out
like the eye keeps track of sun going in
& out of clouds. Then 2 clouds crash

The world is going at a nomad's pace
its face you find routine
& then, surprise!
none other than I experience
finding you. This is what does happen
beauty rings the ear,
 vernacular

I hope you see how crucial intrusions are
for what I mean may be clearer more insistent
because my eyes sigh in debt to yours.

Untitled, 1978
Collage, 14 x 10 3/4 in.
Collection of the artist

Joe Brainard

Peter Frank

The Orgasm of Reason
for Ted Stamm

What we leave in the intense device,
a circle on our rapture, a throw
to the numbers at ground level,
pretend at seasonsful of mitosis,
long lines at the headworks,
stones right away, jokes around
a shrapnel bush along a glide
for January, for free, the
day-long brevity a happenstance
inaction we find excusable at best,
I mean, have you heard the songs
I've meant to sing upon the skins
of lateral assassins, the checkered
careers we almost left behind?
Um, you got it now, you want it
"just the way it always was, just
the way you thought it ought to be,
just the way you painted it to
get exactly like." So what?
So wait! It clicks! It's clicking
in the lap of schists. Its
clicking in the lap of schists has
broken through the rainbow scars.
And somehow it stays broken through
the rainbow scars of weekends past.

November 1977

Dodger-44, 1978-79
NRB oil on canvas, 40 x 111 in.
Hal Bromm Gallery, New York

Ted Stamm

Peter Frank

Parergon: Deadline City

for Tobi Zausner

There is neither any sky nor any limit. Buttons insulated
from the rain stand back to back in front of our wishing
they stood back to back. Sad bamboo! A man dreams,
and in his dream he feels himself aquiver, confounded
by some abreaction he'd never felt. "There's nothing

left behind but a tremendous clock," he thinks, "and
it only counts the seconds. I would rather be alone
in these airfuls of place than accompanied by
even the most meticulously sympathetic wench . . . er,
wretch." He wakes up. He passes through. He's had his day.

Scurrilous logs loom past the fresco, glazed rectories
amidst the hide go loose, lusty knuckles breaking
up the leaded pistol scamp, change veins! Torrid movie
liver jacks the ball at once, up twice, enthralls
the cactus lady's lips (made of pure naugahyde

and costing next to zilch.) A floating Indian returns.
That mountain is made entirely of straw. The Indian
is, too. But here in the dogmobile? Akin to
leper hokum? Akin to something else? Partway
smoking single rictus lips? Blood sugar songs?

With the institute knocking at my foot,
with the late gray drawings lying on their sides,
with the confused setting up a percussion in the jailyard,
with the actress shying away from the nightpainted window,
the ideal idle theories collapse into a heap, and

"Grapefruit," says the car, "I've spent all day watching
a garbage bag embrace a tennis racket aboard an airplane
within another airplane, that one evidently painted
on the flank of yet *another* airplane." The band of snaps
collapses: the once clean field's now a mass of heaps.

At present I am reading this philosopher (or poet,
I'm not sure how he—no, she!—is classified) who is
proposing "a language of hiccups," and seems to be
convinced that such a mode of speech (such as it—
or she, or he, or they—may be) will save the world! the

best thing since Esperanto! The flaws are obvious: things
like lack of inflection and the fact that a run-on sentence
might suffocate the speaker—framed as the speaker is by
a frame around the frame, the lack of celestial citrus,
the goal forgotten in the escape . . . Anywhere farther, father?

"This renders me victorious. This keeps me pusillanimous.
This maintains my consanguinity. This here is my torsion.
That's an adumbration, there, and over yonder, nestled
'midst the hills, a colloquial collateral, resembling
in its own prosthetic manner a lean-to made of

charlatan juice." The reviving buildings winkle in
the sun's glancing heat. The bookish gray stutterer
watches the blue lightning bolt kiss the sisters. Echoes
of Mannerist epochs rake the sky like jet planes off
to war. Today is not an adequate substitute for yesterday.

May 1979

The Poet Drinks, 1978-79
Pencil and pastel on paper, 28 x 42 in.
Collection of the artist

Joe Brainard
Born 1942, Salem, Arkansas

Eight untitled collages, 1975-78
Each 14 x 10 3/4 in.
Collection of the artist

Rudy Burckhardt
Born 1914, Basel, Switzerland

New York Details, 1979
Eight black and white photographs
Six 10 x 14 in., two 14 x 10 in.
Collection of the artist

Pavement, 1979
Oil on canvas, 28 x 74 in.
Collection of the artist

Canyons, 1979
Five black and white photographs
Each 14 x 10 in.
Collection of the artist

Flatiron Building Reflections, 1979
Five black and white photographs
Each 14 x 10 in.
Collection of the artist

Willem de Kooning
Born 1904, Rotterdam, Netherlands

Water . . . Soft Banks and a Window, 1975
Oil on canvas, 80 x 70 in.
Xavier Fourcade, Inc., New York

Untitled XXII, 1977
Oil on canvas, 70 x 80 in.
Xavier Fourcade, Inc., New York

Jim Dine
Born 1935, Cincinnati, Ohio

Mabel, 1977
Twelve etchings with text by Robert
Greeley, edition of 60
Each 19 1/2 x 15 in.
Pace Editions, New York

Anne Dunn
Born 1926, London, England

Bay of Chaleur, 1979
Colored ink on paper, 35 1/2 x 49 1/4 in.
Fischbach Gallery, New York

The Studio, 1978
Colored ink on paper, 35 1/2 x 49 in.
Fischbach Gallery, New York

Manhattan, 1974
Ink on paper, 18 1/2 x 29 in.
Fischbach Gallery, New York

Robert Fabian
Born 1924, Berlin, Germany

Untitled, 1979
Gouache on paper, 5 1/4 x 5 1/2 in.
Collection of the artist

Untitled, 1979
Gouache on paper, 6 3/4 x 6 in.
Collection of the artist

Untitled, 1979
Gouache on paper, 5 3/4 x 5 3/4 in.
Collection of the artist

Untitled, 1976
Gouache on paper, 4 1/2 x 4 1/2 in.
Collection of the artist

Untitled, 1979
Acrylic on canvas, 48 x 42 in.
Collection of the artist

Untitled, 1979
Acrylic on canvas, 40 x 48 in.
Collection of the artist

Untitled, 1978
Acrylic on canvas, 60 x 48 in.
Collection of the artist

Rafael Ferrer
Born 1933, San Juan, Puerto Rico

Luna, 1976
Mixed media, 96 x 120 x 120 in.
Nancy Hoffman Gallery, New York

A uf, 1979
Crayon on navigational chart
44 1/2 x 60 1/2 in.
Nancy Hoffman Gallery, New York

Jane Freilicher
Born 1924, New York

Cat on Velvet, 1976
Oil on canvas, 32 x 40 in.
Fischbach Gallery, New York

Flowering Cherry, 1978
Stencil print, 30 x 30 in.
Fischbach Gallery and
Orian Editions, New York

The Gardeners, 1977-78
Oil on canvas, 51 x 77 in.
Fischbach Gallery, New York

Red Grooms
Born 1937, Nashville, Tennessee

Flowers of Evil, 1969
(in collaboration with Kenneth Koch)
Mixed media, 35 x 23 in.
Marlborough Gallery, New York

At the Railway, 1969
(in collaboration with Kenneth Koch)
Mixed media, 23 x 35 in.
Marlborough Gallery, New York

Stage set for Kenneth Koch's play
The Red Robins, 1978
Wood, 12 x 10 x 4 ft.
Marlborough Gallery, New York

Philip Guston
Born 1913, Montreal, Canada

Allegory, 1975
Oil on canvas, 67 1/2 x 72 3/4 in.
David McKee Gallery, New York

Midnight Pass Road, 1975
Oil on canvas, 67 1/2 x 97 in.
Private collection

Ira Joel Haber
Born 1947, Brooklyn, New York

*My Landscape Grows Older When I'm
Not with You*, 1974
Mixed media, 8 1/2 x 120 x 12 in.
Collection of the artist and
Pam Adler Gallery, New York

Yvonne Jacquette
Born 1934, Pittsburgh, Pennsylvania

Vertiginous Greens, 1977
Oil on canvas, 48 x 60 in.
Lehman Brothers, Kuhn Loeb,
New York

Irving Place Intersection, 1975-76
Oil on canvas, 70 x 80 in.
Brooke Alexander, Inc., New York

Jasper Johns
Born 1930, Augusta, Georgia

Study for *Skin with O'Hara Poem*, 1963-65
Lithograph, edition of 30, 22 x 34 in.
Collection of the artist

High School Days, 1969
Sheet lead, glass mirror, 23 x 17 in.
Gemini G.E.L., Los Angeles

The Critic Smiles, 1969
Sheet lead, gold casting, tin leafing
23 x 17 in.
Gemini G.E.L., Los Angeles

Bread, 1969
Cast lead, sheet lead, paper, oil paint
23 x 17 in.
Gemini G.E.L., Los Angeles

No, 1969
Four color lithographs with lead collage,
embossed, mounted to stretcher bar,
and framed, 56 x 35 in.
Gemini G.E.L., Los Angeles

Flag, 1969
Sheet lead, 17 x 23 in.
Gemini G.E.L., Los Angeles

Alex Katz
Born 1927, New York

Rudy and Yvonne, 1977
Oil on canvas, 72 x 96 in.
Marlborough Gallery, New York

Edwin, 1972
Oil on canvas, 96 1/4 x 72 1/4 in.
Marlborough Gallery, New York

Fay Lansner
Born Philadelphia, Pennsylvania

Women in Space (triptych), 1978-79
Oil on canvas, each panel 60 x 60 in.
Collection of the artist

Rosemary Mayer
Born 1943, Ridgewood, New York

Winter Flower, 1976
Watercolor on rice paper, 13 x 11 in.
Collection of the artist

Winter Flower, 1976
Watercolor on rice paper, 13 x 10 in.
Collection of the artist

Insistently Reappearing, 1976
Watercolor on rice paper, 24 x 20 in.
Collection of the artist

Insistent Volumes, 1976
Watercolor on rice paper, 26 x 19 in.
Collection of Awilda and
Michael Bennett, New York

June Flowers, 1976
Watercolor, 31 x 47 in.
Collection of Robert C. Hobbs,
New York

Lynn O'Hare
Born 1939, Wichita, Kansas

Market Stall, 1977
Watercolor, 10 x 14 in
Collection of the artist

Acapulco Gate, 1977
Watercolor, 10 x 14 in.
Collection of the artist

Market Corner, 1977
Watercolor, 10 x 14 in.
Collection of the artist

Tile and Flowers, 1975
Watercolor, 10 x 14 in.
Collection of the artist

Jalousie, 1977
Watercolor, 10 x 14 in.
Collection of the artist

Ranunculus-Broom, 1975
Watercolor, 10 x 14 in.
Collection of the artist

Belly, 1975
Watercolor, 8 x 10 1/4 in.
Collection of the artist

Blind, 1979
Watercolor, 18 3/4 x 22 1/4 in.
Collection of the artist

Lily III, 1979
Watercolor, 16 3/4 x 22 1/2 in.
Collection of the artist

Patricia Padgett
Born 1937, Tulsa, Oklahoma

Four untitled watercolors, 1977
Each 14 x 10 in.
Collection of the artist

Four untitled watercolors, 1977
Each 10 x 8 in.
Collection of the artist

Two untitled watercolors, 1977
Each 7 x 5 in.
Collection of the artist

Robert Rauschenberg
Born 1925, Port Arthur, Texas

Half a Grandstand (Spread), 1978
Mixed media, 84 x 252 x 2 in.
Collection of the artist

Larry Rivers
Born 1923, New York

Poem and Portrait of John Ashbery, 1977
Acrylic and pencil on canvas, 76 x 58 in.
Marlborough Gallery, New York

George Schneeman
Born 1934, St. Paul, Minnesota

Allen (Ginsberg), 1978
Fresco on cinderblock, 8 1/2 x 7 1/2 in.
Holly Solomon Gallery, New York

Rene (Ricard), 1978
Fresco on cinderblock, 8 1/2 x 7 1/2 in.
Holly Solomon Gallery, New York

Ted (Berrigan), 1978
Fresco on cinderblock, 8 1/2 x 7 1/2 in.
Holly Solomon Gallery, New York

John Seery
Born 1941, Cincinnati, Ohio

Gamut, 1976
Acrylic on canvas, 116 x 210 in.
Max Hutchinson Gallery, Houston

Sylvia Sleigh
Born Llandudno, Wales

A.I.R. Group Portrait, 1978
Oil on canvas, 76 x 83 in.
Collection of the artist

Ira Joel and John Perreault Feb. 1, 1972
Oil on canvas, 37 x 49 in.
Collection of the artist

Ted Stamm
Born 1944, Brooklyn, New York

Dodger-44, 1978-79
NRB oil on canvas, 40 x 111 in.
Hal Bromm Gallery, New York

Tobi Zausner
Born 1942, New York

Travelogues, 1974-76
Oil on canvas, 58 x 48 in.
Collection of the artist

The Poet Drinks, 1978-79
Pencil and pastel on paper, 28 x 42 in.
Collection of the artist

The Winner, 1978
Pencil and pastel on paper, 28 x 42 in.
Collection of the artist

Bodhisattva, 1978-79
Pencil and pastel on paper, 28 x 42 in.
Collection of the artist

Photographs: pages 35, 47, 55 by Jacob Burckhardt; page 61 by Bevan Davies; page 77 by eeva-inkeri; page 65 by Bruce C. Jones; page 39, 41 by Al Mozell; page 51 by Eric Pollitzer; pages 43, 73 by Lloyd Rule; page 45 by Steven Sloman Fine Arts Photography.